ALSO BY LINDA GORDON

*Woman's Body, Woman's Right: A
Social History of Birth Control in
America* (revised 3rd edition
published as *The Moral Property of
Women: A History of Birth Control
Politics in America*)

*Cossack Rebellions: Social Turmoil in
the Sixteenth-Century Ukraine*

*Heroes of Their Own Lives: The Politics
and History of Family Violence*

*Pitied but Not Entitled: Single Mothers
and the Origins of Welfare*

The Great Arizona Orphan Abduction

As Editor

*America's Working Women: A
Documentary History, 1600 to the
Present* (with Rosalyn Baxandall and
Susan Reverby)

*Women, the State, and Welfare:
Historical and Theoretical Essays*

*Dear Sisters: Dispatches from the
Women's Liberation Movement* (with
Rosalyn Baxandall)

ALSO BY GARY Y. OKIHIRO

*Japanese Legacy: Farming and
Community Life in California's Santa
Clara Valley* (with Timothy J. Lukes)

*Cane Fires: The Anti-Japanese
Movement in Hawaii, 1865–1945*

*Margins and Mainstreams: Asians in
American History and Culture*

*Whispered Silences: Japanese
Americans and World War II* (with
Joan Myers)

*Storied Lives: Japanese American
Students and World War II*

*A Social History of the Bakwena and
Peoples of the Kalahari of Southern
Africa, Nineteenth Century*

*Common Ground: Reimagining
American History*

*The Columbia Guide to Asian
American History*

IMPOUNDED

 W. W. NORTON & COMPANY

NEW YORK · LONDON

Dorothea Lange

and the Censored Images
of Japanese American Internment

EDITED BY LINDA GORDON AND GARY Y. OKIHIRO

For information about permission to reproduce selections from this book, write to Permissions, W. W. Norton & Company, Inc., 500 Fifth Avenue, New York, NY 10110

Manufacturing by The Courier Companies, Inc.
Book design by Rubina Yeh
Production manager: Andrew Marasia

Library of Congress Cataloging-in-Publication Data

Lange, Dorothea.
 Impounded : Dorothea Lange and the censored images of Japanese American internment / Dorothea Lange ; edited by Linda Gordon, Gary Y. Okihiro.
 p. cm.
 ISBN13:978-0-393-06073-7 (hardcover)
 ISBN10: 0-393-06073-X (hardcover)
 1. Japanese Americans—Evacuation and relocation, 1942–1945—Pictorial works. 2. World War, 1939–1945—Japanese Americans—Pictorial works. 3. Censorship—United States. I. Gordon, Linda. II. Okihiro, Gary Y., 1945– III. Title.
 D769.8.A6L35 2005
 940.53′089′956073—dc22

 2005049835

W. W. Norton & Company, Inc., 500 Fifth Avenue, New York, N.Y. 10110
www.wwnorton.com

W. W. Norton & Company Ltd., Castle House, 75/76 Wells Street, London W1T 3QT

1 2 3 4 5 6 7 8 9 0

CONTENTS

AUTHORS' NOTE

For Gordon Hirabayashi, Minoru Yasui, Fred Korematsu, Mitsuye Endo, and others who have struggled against internment without trial.

The captions for these pictures were written, often hurriedly, by Dorothea Lange. We have eliminated repetition but otherwise they appear exactly as she wrote them.

All photographs of the internment from U.S. National Archives; reproduction by Photo Response.

Photographs in Linda Gordon's essay include some from the Library of Congress (pages 13 and 14).

IMPOUNDED

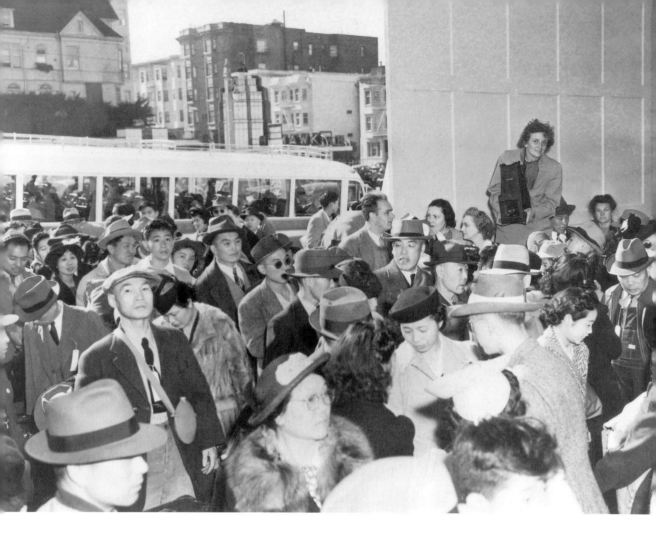

A rare image of Dorothea Lange at work during the first few days
of the internment. She appears in the upper right-hand corner
with her camera. San Francisco, California.

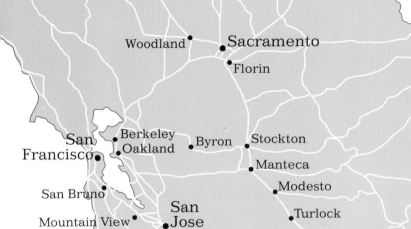

LOCATIONS OF
DOROTHEA LANGE'S PHOTOGRAPHS

NEVADA

Woodland · Sacramento
· Florin

San
Francisco · Berkeley · Byron · Stockton
Oakland · Manteca
· Modesto
San Bruno · Turlock
Mountain View · San
Jose · Merced

Santa Cruz · Watsonville

Monterey · Salinas · Fresno · Manzanar

CALIFORNIA

MILEAGE
Oakland – Sacramento...92 miles
Oakland – Stockton...73 miles
Oakland - Bakersfield...254 miles
Oakland - Fresno..160 miles
Fresno - Manzanar..140 miles
Manzanar is at the north end of Death Valley

Dorothea Lange Photographs the Japanese American Internment

LINDA GORDON

Dorothea Lange was one of the great documentary photographers and one of the strongest influences in creating our contemporary conception of documentary photography. Her best-known work, photographs of migrant farmworkers and sharecroppers of the Depression of the 1930s, is so widely published that those who do not know her name almost always recognize her pictures. She has been the subject of many major museum exhibits. Several dozen art books feature her photographs and they also appear as illustrations in hundreds of books, magazines, even advertisements. Since the bulk of her work was done for the federal or California state government, it is in the public domain and anyone can use it gratis for any legal purpose whatsoever.

Yet few of her photographs of the Japanese internment are known to the public. These were also commissioned by the federal government, but have never been published as a collection and approximately 97 percent of them have never been published at all. The pictures were suppressed for the duration of World War II: US Army Major Beasley actually wrote "Impounded"

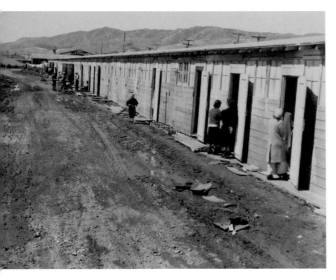

across some of the prints (luckily, not on the negatives).[1] They were never actively distributed, unlike the work Lange did for the Farm Security Administration, which was widely circulated and published. After the War ended, the army quietly placed her internment photographs in the National Archives. Only once were any significant number of these photographs published: Richard Conrat, one of Lange's assistants and protegés, together with his wife, Maisie Conrat, produced *Executive Order 9066* as a report of the UCLA Asian American Studies Center in 1972.[2] A few of Lange's pictures can be found in general histories of the internment. But until now no coherent selection from them has been published or exhibited.

These photographs exemplify Lange's mastery of composition and of visual condensation of human feelings and relationships. They also unequivocally denounce an unjustified, unnecessary, and racist policy. Lange's critique is especially impressive given the political mood of the time—early 1942, just after Japan bombed Pearl Harbor. Hysterical fears of further Japanese attacks on the West Coast of the United States combined with a century of racism against east Asians to create a situation in which, as Carey McWilliams, later to become the editor of *The Nation*, remarked, you could count on your fingers the number of "whites" who spoke publicly against sending Japanese Americans to concentration camps.[3] Even the liberal Dr. Seuss contributed a racist anti-Japanese cartoon.[4]

For me this book grew out of a larger project, a biography of Dorothea Lange, so I think about her Japanese internment work with questions about the overall trajectory of her photography. I wondered particularly, how did she arrive at such an exceptional antiracist consciousness? In the 1940s, demeaning racial stereotypes of peoples of color saturated white culture. And what was the origin

of convictions strong enough to lead her to such an unpopular stand, to the extent even of criticizing a president—Franklin Delano Roosevelt—to whom she was so loyal?

Lange's childhood in Hoboken, New Jersey, where she was born in 1895, might have depressed someone with less innate drive, but it made the young Dorothea Nutzhorn unusually independent and determined. Two traumas hit during her school years: polio at age seven, which left her slightly disabled, with a somewhat crabbed right foot, and her parents' separation when she was twelve. Both were made worse, inadvertently, by her mother's attitudes: Joan Nutzhorn urged Dorothea to hide and disguise her disability, and interpreted the marital separation as a husband and father's desertion, positioning herself and her children as victims. Mrs. Nutzhorn was an educated woman and managed to retain her middle-class status even after the separation and divorce, but when she became the family breadwinner, their standard of living fell. She got a job at a public library on New York's Lower East Side and every day Dorothea rode the ferry into the city with her and attended a school in that neighborhood. Here Lange was, she later recalled, "the only Gentile among 3000 Jews," an experience that convinced her, she said, that she could not excel academically. While waiting for her mother after school, she took to walking the streets in this neighborhood where so much of life was lived outside, absorbing the impertinent, clanging energies, strange to a WASP child, of this early microcosm of globalization. Later her mother became an investigator for the juvenile court system, and the observations she brought home further exposed Dorothea to poverty and racial/ethnic difference. She became steadily more self-reliant, especially after she entered private Wadleigh High School on New York's Upper West Side. With a new friend, Fronzie (Florence Ahlstrom), she began to have independent arts experiences: she attended concerts, watched Isadora Duncan and Sarah Bernhardt perform, visited museums. She was becoming a New Yorker, gaining a New Yorker's interest in high culture and comfort with diversity.

When she graduated from high school, Dorothea informed her mother—seemingly out of the blue—that she was planning to be a photographer. She had

uncles who were lithographers, so she had been introduced to printmaking as a vocation. Already displaying her drive and persuasive power, she found work with several studio photographers, thereby creating an apprenticeship for herself. She somehow persuaded Arnold Genthe, a nationally known art and portrait photographer, to take her on as lab technician and receptionist. So she would have seen his unique photography of Chinese immigrants in San Francisco. She took a course in the best photography school in New York, that of Clarence White, who also happened to be uniquely supportive of women learning the craft.

In the winter of 1917–18, she took off with Fronzie on a trip "around the world," but got no farther than San Francisco. She lived the rest of her life in the Bay Area. Here she appropriated her mother's family name, Lange.[5] She got a job doing photofinishing and joined a camera club. She made photographer friends, among them the unconventional Imogen Cunningham, who became Dorothea's close friend for life, and the dashing photojournalist Consuelo Kanaga, who lived in a Portuguese neighborhood and later became noted for her portraits of African Americans. In short order Lange established a portrait studio of her own and married a well-known western artist, Maynard Dixon.

Twenty years her senior, the lean, tall Dixon dressed in black with cowboy boots and hat, a dashing and magnetic figure at the center of a bohemian crowd of artists. This diverse and sophisticated crowd, which included one Mexican and several European painters, socialized with their women at an Italian restaurant, where they painted ironic caricatures of themselves on the walls and drank a great deal of red wine. They weren't particularly interested in politics, mainstream or radical, but they prided themselves on their eccentricity and disregard for conventionality. Lange and Dixon went skinny-dipping and she made scores of pictures of their two small sons playing naked—nudity symbolized freedom in this subculture. Lange's business snowballed to great success, and her photographic marriage of fine composition with a knack for capturing subjects in informal, relaxed postures drew in a clientele of San Francisco's rich and sophisticated art patrons. Accompanying Dixon on trips in the western countryside and to New Mexico, she experienced his rather romantic, even orientalist fascination with Indians. Dixon and others among

their crowd had sojourned in Mexico, where they discovered the arts renaissance released by the 1910 revolution, and when Diego Rivera and Frida Kahlo came to San Francisco in November 1930 they stayed with close friends of Dixon and Lange and socialized with their crowd.

The Depression clobbered these painters and sculptors who lived from commissions, exhibits, and sales. Escaping, Dorothea and Maynard and their children went to Taos to weather the storm—until the economic crisis ended, they thought. They stayed in a two-room adobe house near the Taos Indian pueblo for seven months. When they returned, the Depression was deeper than ever. One-fifth of Californians were on relief by 1933. Drawn by the rumblings of social protest and by the shrinkage of her clientele, Lange began to leave the studio and photograph in the streets. She made pictures of the breadlines, the unemployed sleeping on park benches, and the longshoremen's strike of 1934. Thirty years later she recalled the many strikes she had been aware of: Greyhound bus drivers, carpenters, oil workers, steelworkers, boilermakers, farmworkers. She became a supporter of unions and union shops: "all these people had to join the union. It was a very great thing."[6] She wasn't unique in her newfound concern for poor and working-class people—a very large proportion of photographers and artists moved to the left at this time, including several from Dixon's and Lange's crowd. She even persuaded Dixon to make some paintings of these subjects, but he disliked doing it, while she grew happier and more vigorous as a street photographer.

At this time, however, her photography exhibited no particular focus on people of color or the workings of race. That was to change under the influence of Paul Schuster Taylor, her second husband. Taylor, a progressive professor of economics at the University of California–Berkeley, was the only Anglo scholar to study Mexican Americans in the 1920s. As much an ethnographer as an economist, he talked with and listened to his subjects as well as collecting data about their immigration and work histories; he had been carrying a camera and making pictures to illustrate his research since 1919, and in 1927 when he undertook a massive survey of Mexican labor in the United States, he made photographs part of his data.[7] His first glimpse of Lange's work in a small Oakland gallery in 1934 thrilled him and he immediately sought her out. He got

her hired on a project he was doing for the state relief agency; they soon fell in love, divorced their spouses, and married, forming a personal, professional, and political partnership that endured to her death in 1965. Through Taylor, Lange became aware of the exploitative and even brutal treatment of migrant farmworkers, especially those "nonwhites" of Mexican, Filipino, and Japanese ancestry. Well connected in the federal Department of Agriculture, Taylor introduced Lange's work to the head of a documentary photography project within the Farm Security Administration (FSA), who hired her immediately.

The FSA project to document rural poverty put its photographers on the road, sometimes for months at a time. The excursions were grueling. Lange traveled repeatedly through the Imperial and San Joaquin valleys photographing migrant farmworkers and Dust Bowl refugees, in the scorching heat of summers before air-conditioning. She moved throughout the Deep South, braving Mississippi and Alabama white hostility as she photographed black as well as white sharecroppers and wage laborers growing cotton and tobacco and distilling turpentine. In the summer of 1936 she logged 17,000 miles. Defying contemporary stereotypes about the disabled, Lange had considerable physical strength. She often climbed on top of her old Ford station wagon to photograph. She slept little, developed film in motel bathrooms with no ventilation, and worried that the heat and humidity would damage her film.

The photographers' assignment was to document the need for FSA programs, and Lange enthusiastically accepted the task. Such was her admiration for FDR and the New Deal that she had no problem with serving up to the government what it ordered. At first she dutifully "documented" migratory workers' camps, alternatively mired in mud or layered with dust; she pictured filthy water supplies and children covered with flies. But she soon drew upon her area of greatest mastery: always a portrait photographer, Lange turned toward the poor the same eye she had previously directed toward the rich. She made portraits of farmworkers within the same visual conventions she used in her studio but the change in subject matter made them, at that time, unconventional, startling, gripping. Other FSA photographers were influenced by her and a new style was being pioneered by the most unexpected of style makers, the federal government.

It was new at this time to bring dignified, contemplative portraits of the lower classes to a broad public.[8] Many of Lange's 1930s photographs were reproduced in mass-circulation media. She did not think of herself as an artist at this time, only as an expert craftswoman, and ironically this diffidence probably contributed to her becoming an artist: that is, she escaped pressures to fit in to the market-driven, museum-driven standards of what constituted art. She was

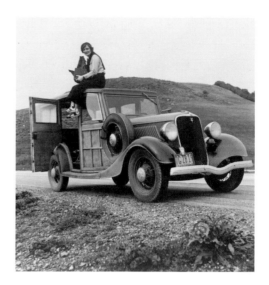

comfortable being paid by the federal government instead of individual clients. And she was comfortable with her job description: to bring rural Depression conditions to public attention and to do it in a manner that showed its victims as citizens, worthy of help and able to make use of it.

That job description raises the question, what is documentary photography? The term was new in the 1930s and even the concept was familiar only within a small network of social reformers. European modern photographers began to speak of photographic "documents" as early as 1910, defining their work against the romantic, fuzzy photography called "pictorialist" that then prevailed. In the United States, Jacob Riis and Lewis Hine pioneered a photography that showed the wretched conditions of poor and working-class people in order to gather support for progressive social reform. American documentary was never neutral or apolitical, but an exhortation to action. At the same time some photographers promoted a mystique that documentary photography was merely an "objective" recording of "reality." Walker Evans, Lange's colleague at the FSA, considered it "a stark record . . . [of] actuality untouched. . . . "[9] A *document* was supposed to be disinterested, as if it were possible for human beings to make images without point of view. Lange frequently contradicted herself regarding the documentary.

Carping with her friend photographer Minor White, she wrote, "I object to this misconception and am surprised that you too repeat it. Documentary photographers are not social workers. Social reform is not the object of documentary photography. It may be a consequence because it can reveal situations and can be concerned with *change*. Its power lies in the evidence it presents not in the photographer's conclusion for he is a witness to the situation not a propagandist or an advertiser. A documentary photography has a responsibility of keeping the record and to keep it superbly well."[10] But Lange also acknowledged being a propagandist: "Everything is propaganda for what you believe in, actually, isn't it? . . . I don't see that it could be otherwise. The harder and the more deeply you believe in anything, the more in a sense you're a propagandist. Conviction, propaganda, faith. I don't know, I never have been able to come to the conclusion that that's a bad word."[11]

The tension in documentary photography between telling the "objective" truth and arguing a point of view continues when you consider photographic technique. Professional photographers don't "take" pictures but make them. Every camera adjustment—speed, aperture, filter, frame, depth of focus, angle of vision, etc.—shapes the outcome, as do the myriad manipulations made in the darkroom in developing and printing.

The only resolution of this tension must be approximate. Some forms of manipulation, as when Soviet publishers removed Trotsky from earlier pictures in which he had stood next to Lenin, produce direct lies. But we should never treat a photograph as something free of human perspective—nor would that be desirable. Lange's photographic work was saturated with conviction.

And what exactly were those convictions? I would characterize them, and those of the FSA as a whole, as democratic-populist nationalism. I mean "populist" in the most generic sense: opposing political domination by big business or other elites. Since populisms have produced both left-wing and right-wing versions, I use the modifier "democratic" to make clear the progressive, leftward orientation of these New Dealers. I am aware that nationalism is a label not often attached to the United States by historians, an absence that is one of the lingering blind spots of American exceptionalism and, more recently, great-power myopia. Even critics of U.S. expansionism and

foreign policy are more likely to refer to U.S. imperialism than to U.S. nationalism. This omission keeps some aspects of American political culture hidden, particularly at the intersection between domestic and foreign policy. Even democratizing impulses and struggles in the United States have been rooted in assumptions about and loyalties to an imagined community, called "American," which was often assumed superior and therefore entitled. New Deal nationalism valorized an activist state and the obligations of all to help alleviate poverty and economic insecurity. It did so, however, by soft-pedaling any resemblance to European social democracy and constructing American history and American "character" as not only politically unique but politically superior: the United States was founded in democracy and its population had a special talent for democracy. Even American religiosity was harnessed to serve this nationalism. Henry Wallace, who was secretary of agriculture and then vice president while Lange did this work, rhetorically rooted America's inevitable progress toward ever greater democracy in the Old Testament.[12]

Moreover, "American" has rarely been without racial/ethnic content; it often meant, simply, WASP. The struggle to make "American" an inclusive nationality has been ascendant in some times and places, losing or even defeated in others. The FSA's and Lange's vision of Americanism sought to avoid these discriminatory exclusions. Just as they hoped to bring common people into political participation, so they also hoped to bring the country's diverse racial/ethnic groups into Americanism. In this respect Lange was not unique; she was one of thousands of artists who participated in spreading and strengthening this democratic culture, many of them employed by a federal relief agency, the WPA.

But more than most cultural

workers, more than almost any other white ones, Lange actively challenged the enduring stream of racism—it would have been called race prejudice at the time—that has been part of America's nationalism. This stream is by no means just one polluted current in an otherwise clean river. Often it has been, rather, part of the essence of the American identity, and nowhere more than in California, where "American" became a synonym for

white, where citizens of color were for long periods of time transformed into aliens by whites, where the great majority of immigrants were not even eligible for citizenship. A few antiracist New Deal administrators, such as John Collier, Harry Hopkins, Harold Ickes, and Mary McLeod Bethune, tried to use federal programs to erode racial domination, but most New Deal programs excluded groups categorized as nonwhite and capitulated to the political power bases of racial domination. This suppression is today often categorized as racism. It needs to be understood also as nationalism. The Depression gave rise to several programs of deporting or "repatriating" at least two of these "alien" groups, Mexicans and Filipinos. These policies were part of American populism too.

Lange's nationalism, by contrast, was not only inclusive but specifically antiracist. She made more pictures of people of color than any other FSA photographer until Gordon Parks joined the staff.[13] Traveling through the southeastern and southwestern states as well as California, often accompanied by Paul Taylor, who was as expert as anyone on the exploitative conditions of sharecropping, tenant farming, and migratory farm labor, she got an education. She saw and photographed how racisms intensified and naturalized the exploitation of labor, how they permeated whole regional cultures. She saw how local political magnates enforced the exclusion of blacks through intimidation and even terror. She had little control, however, over which of her pictures were distributed to the media: the FSA's selective distribution drew on only a small

fraction of her work, and that fraction was unrepresentative—rather, it was overwhelmingly white. As a result it is her pictures of "Okies" that are best known. Looking back now at Lange's work from a post-civil-rights perspective, we can see her trying to bring African Americans into citizenship through her powers of representation. And the common denominator among all these photographs was respect. Her images of sharecroppers and migrant farmworkers had no less gravitas than her portraits of San Francisco's symphony conductors and corporate executives.

Unlike most New Deal policies, jury-rigged so as not to threaten Southern white racists or challenge their power, Lange tried to expose racism as a relationship and as a structure. The image to the left, of a Mississippi plantation owner and his croppers, is one of her most successful in exposing racial domination because it so precisely aligns spatial relations to power relations, bodies to economic structures. (Lange's work often created visual, spatial expressions of social relationships, both hierarchical and egalitarian, as is evident in the photographs of the internment.) She tried to sell her boss, Roy Stryker, on one project that might have broken through this limitation and would certainly have pushed against it: she proposed a photographic series that would use pictures and words to show the poll tax and its disfranchisement of so many Southerners, white and black.[14] She wanted to relate political freedom to economic freedom. Stryker would have none of this poll-tax idea—he thought, probably correctly, that it would make powerful Southern Democratic politicians determined to crush the FSA.

Lange worked for the FSA off and on through 1939, then applied for and received a Guggenheim Fellowship for a different kind of rural photographic project. Emphasizing the positive aspects of rural life, she was following Paul Taylor's ideological loyalty to small family farms as fundamental to a democratic and ethical society. Her application stated her theme as "the relation of man to the earth and man to man, and the forces of stability and change in communities of contrasting types"—the Hutterites in South Dakota, the Amana society in Iowa, and the Mormons of Utah. These three religious communities all rejected the twentieth century, attempting to remain socially cohesive in order to fend off modern, urban, secular, and, to some degree, commercial values. She was

thrilled with the opportunity—as the first female photographer to get a Guggenheim—and plunged into the work in July 1941 expecting (and expected by the Guggenheim Foundation) to spend a year on the project. The photographs that emerged were mainly sunny and complacent, despite some critical notes she took on bleakness and bondage among the Hutterites. Years later she considered these pictures poor. She recalled being enervated by the heat and general exhaustion, and in retrospect it is clear that she was beginning to feel the effects of illness that would shadow her last decades. But one wonders, too, if it were not the case that her best work was always probing, critical, complex. She didn't do sunny nearly as well.

Then imperial Japan bombed Pearl Harbor. Major California media and political leaders presented the Japanese enemy in racial rather than ideological terms. Rumors of spies, sabotage, and attacks circulated widely. A few authenticated attacks—for example, in February 1942 submarines shelled a Santa Barbara oil refinery; in June a submarine shelled the Oregon coast; in September a submarine launched incendiary bombs near Brookings, Oregon—escalated the fear-driven hysteria, although no one was hurt and damage was minimal. But significantly, the executive order calling for evacuation came out *before* any of these attacks occurred. Military leaders ratcheted up the anti-Japanese fever. General John L. De Witt, head of the U.S. Army's Western Defense Command, opined that "the Japanese race is an enemy race and while many second and third generation Japanese born on American soil, possessed of American citizenship, have become 'Americanized,' the racial strains are undiluted. . . . The very fact that no sabotage has taken place to date is a disturbing and confirming indication that such action will be taken."[15] That kind of hysterical illogic went largely unchallenged.

In February 1942 FDR ordered the internment of the Japanese Americans, regardless of their citizenship, and the War Relocation Authority (WRA) was established on March 18 to organize their removal. The WRA hired Dorothea Lange to document the program photographically. The WRA was then headed by Milton Eisenhower, brother of Dwight, who had previously worked for the

Department of Agriculture; he might well have been acquainted with Paul Taylor and Lange's reputation at the FSA had probably reached him. Therein lies an irony. No doubt she had received an enthusiastic recommendation because her previous work had so perfectly advanced the earlier agency's agenda; the WRA probably expected the same now, but did not get it.

Lange was eager for the job. Did she know in advance that she would be a subversive employee, I wonder? Apparently no one ever asked her that question, and there is no written evidence. She asked for and received a three-month postponement of her Guggenheim Fellowship, not knowing that she would be unable to take it up again for ten years. She started to photograph the moment the roundups began on March 22 and was officially on the WRA payroll as of April 2.

During April and May she photographed nonstop, taking only three days off, although some of her time was spent developing and printing at home, then sending photographs to Washington in batches. Most of her trips were close enough to her Berkeley home that she returned at night, but her workdays frequently extended from 7:30 A.M. to 9:30 P.M.[16] There were no freeways then, so driving was slow. Even when she returned well after suppertime, she and her assistant, Christina Page, often went directly down to her darkroom to process film. Lange probably considered these working conditions relatively comfortable compared to her FSA road trips, and her domestic arrangements were easier because by now her children and stepchildren were teenagers. On several occasions, in fact, she took along one or the other of her sons, and Paul was with her on at least four trips.[17] She covered roundups and forced removals in San Francisco and Mountain View, west of San Francisco Bay; in Oakland, San Leandro, Hayward, and Centerville in the East Bay; and in the San Joaquin Valley in Woodland, Sacramento, Florin, Lodi, Byron, Stockton, Turlock, and Fresno. She photographed at temporary "assembly centers" in San Bruno, Stockton, Sacramento, and Salinas and in late June and early July worked at the long-term concentration camp at Manzanar.

Lange always preferred to work with an assistant—in fact, it was quite a hardship for her to work alone. When in a car she was continually watching for photographic opportunities, so it was better for someone else to drive and make

the sudden skidding stops that Lange called for. (One assistant couldn't stand to let Dorothea drive because she drove so slowly, never over 20 mph and constantly on the lookout for picture prospects, that their trips took too long.) She often needed an elevated position from which to get the broader view she wanted, so she had had a platform built on the roof of her old station wagon—in fact, she'd been known to sit on the roof while her assistant drove along slowly. (She usually carried a small stepladder in the car.) She needed help with her heavy equipment—during the internment project there were sometimes four cameras in the car. Her workhorse camera was a Rolleiflex, a twin-lens reflex camera, which used $2\frac{1}{4}" \times 3\frac{1}{4}"$ roll film. She carried an older Rolleiflex that had been Paul's during World War I and during his field work on Mexican labor (it was hard to use because there was a difficult knob to turn to advance the film), just in case hers malfunctioned. She also packed the heavier cameras she had been accustomed to: a Zeiss Juwell, urged upon her by Ansel Adams, and a Graflex, her old favorite for studio work but too heavy to carry around for any length of time. These were view cameras, with negative sizes of $4" \times 5"$ or so. The assistant would make sure that each camera was always loaded with film so that Lange could switch cameras quickly. She was a magician with the cameras, one assistant recalled, knowing instantly which suited her purpose. Whenever possible she used a tripod, which had to be unfolded, carried, folded again. On the return drive she often slept from exhaustion.[18]

In her documentary work, Lange's photographic technique required putting her subjects at ease. Her skill in this regard amazed those who watched her, though they didn't always emphasize the same aspects of that skill. Most commonly, observers remarked that she could somehow make herself nearly invisible, unnoticed, or at least disregarded by subjects. (One of her interned subjects, photographed quite close to her camera at the head of a line in one of the assembly centers, did not know he was in her picture.[19]) As Lange herself put it, "If I don't want anybody to see me, I can make the kind of face so eyes go off me."[20] This capacity is hard to imagine for those, like me, who never saw her, because it contrasted so with her social personality, which was lively, forceful, sometimes bossy, often charismatic. Lange herself claimed it derived from her physical handicap, which made her unthreatening—a claim that doesn't explain

much, since a disabled person could
just as likely have attracted attention.
Lange never tried to get "candid"
pictures of unaware subjects as FSA
photographers Ben Shahn and Walker
Evans did. More likely her relative
slowness and the large cameras she
used meant that subjects might notice
her but then lose interest. She avoided
35 mm cameras, which required
holding the camera in front of your
eyes; by looking down at a waist-high

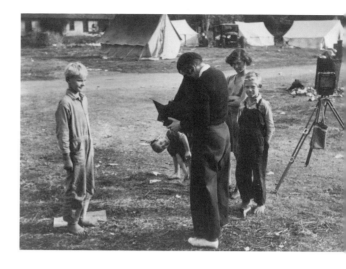

camera to see her image, she could spend most of the time looking at and
talking with her subjects. Oddly, observers also remarked on Lange's
straightforward way of introducing herself to documentary subjects: in her FSA
work she would explain that she worked for the Roosevelt government, and that
the purpose of the photography was to build political support for programs of
relief for the impoverished.

She had to modify this approach in her internment photographs because she
had to negotiate conflicting constraints. First, in the 1930s she had been working
for a government committed to relieving suffering; now she was documenting a
suffering created by the government in an operation she considered odious. She
typically asked permission of her photographic subjects with the explanation
that she was working for the government and that she believed a true record of
the evacuation would be valuable in the future. Still, she could hardly have been
completely open with her supervisors. She told Quaker protester Caleb Foote, a
leader of the Fellowship of Reconciliation, that she was guilt-stricken working
for the government while this appalling thing was happening.[21] Second, she
faced considerable harassment in trying to do the job. She was the victim of
divided authority over and disagreements about the internment policy within
the federal government, and the obstacles and harassment she faced suggest
that some authorities wanted to force her to quit. The WRA had hired her, but it
was the army that policed the roundup and the camps, and the MPs threw every

possible impediment in her way as she tried to do her job. Even local WRA officials were at times suspicious of what she was doing. Restrictions surrounded her as she worked: no pictures of the barbed wire or watchtowers or armed soldiers guarding the camps. Nothing hinting at resistance within the camps. She was constantly followed. Those in charge tried to keep her from talking with internees;[22] despite weeks of work getting credentials to go to each place she visited, she was constantly hounded and refused access to what she was supposed to photograph. MPs would repeatedly stop her, demanding her credentials, making her lose precious time waiting for their clearance, then arbitrarily declaring certain spaces off limits.[23] Her assistant suspected that this made the internees more willing to cooperate with Lange. (Oddly, none of her assistants or family members were ever asked for credentials, suggesting that the concern was not security.) At the same time the WRA bureaucracy hassled her over mileage records and gas receipts, and made her account for every telephone call. The FSA man in the Bay Area remembered that Lange was unprepared for the rough treatment she received: "The whole thing, the feelings and tempers and people's attitudes, were very complex and heated. . . . "[24] She was required to turn over all negatives, prints, and undeveloped film from this work—then her pictures were impounded for the duration of the war. "I had to sign when I was finished, under oath, before a notary."[25]

Lange developed a particularly adversarial relation with Major Beasley (referred to by some as Bozo Beasley[26]), who tried to catch her in various infractions. Once she gave a photograph to Caleb Foote, who used it as the cover of a pamphlet denouncing the internment. When Beasley found out, he thought he had her. But luckily for Lange, a congressional investigating committee had published the picture, thus putting it into the public domain.[27] Another time Beasley thought he had caught her out in holding back a negative but when he called her in and demanded that she produce the missing negative, she showed him that it was filed just where it ought to have been.[28]

Why did they hire her if they were so nervous about a photographic record? Christina Page remembered being bewildered that the MPs were so uncooperative when Lange was working for the government; when I suggested that perhaps the government had not expected her pictures to be so critical,

Christina responded, "What else was there to show?"[29] But of course "government" was divided—if the army brass in charge had been consulted, Lange would not have been hired. Lange's own retrospective explanation was that they wanted a record but not a public record.[30] Paul Taylor said that making a photographic documentary record was by then "the thing to do" in government.[31] A photographic record could protect against false allegations of mistreatment and violations of international law, but it carried the risk, of course, of documenting actual mistreatment.[32] A measure of how important it seemed to prevent such a calamity was that the internees were forbidden to have cameras. One prize-winning professional Japanese American photographer, Toyo Miyatake, once a student of and assistant to Edward Weston, smuggled a lens, a ground glass, and a film holder into Manzanar. There he built a camera box from scrap wood, disguised it as a lunch box, and photographed clandestinely.[33] We owe much of our understanding of camp life in later years to his initiative and courage.

Paul's perspective further complicated Lange's assignment. Christina Page reported that "Dorothea and Paul were clear in opposition to the forced removal before beginning the project."[34] But Taylor was also hoping to influence policy. He probably reasoned—as he would later do regarding other issues on which he disagreed with authorities—that he could have more impact from inside than from out. His judgment may have been correct, because he appeared "objective" enough to serve as "counselor" to the House Select Committee Investigating National Defense Migration (known as the Tolan Committee) when it held hearings on the West Coast in February and March 1942.[35] He also considered it vital that Dorothea be discreet enough to be allowed to complete a photographic record. In any event, he proceeded with caution

and infused Lange with that caution, counseling her not to defy the military authorities in any way.

Taylor agreed to write about the internment for *Survey Graphic*, a progressive monthly social-reform magazine. "This is the hardest assignment you ever gave me to wrestle with," he wrote the editor. "Between indifference and heedlessness,[36] and military and civilian, and . . . humaneness and nastiness and fears and principles and imponderables its a very tough one to try to handle."[37] In the article he finally produced, Taylor asserted a rational basis for the fears of Japanese American disloyalty: "it is extremely doubtful whether [Japanese Americans] could withstand the ties of race and the affinity for the land of . . . forebears. . . . To withstand such pressure seems too much to expect of any national group almost wholly unassimilated, which has preserved in large measure to itself, its customs and traditions . . . characterized by strong filial piety."[38] But Taylor condemned some of the egregious legislative proposals being introduced, such as a U.S. Senate bill that would have stripped Japanese Americans of citizenship. He endorsed a proposal from Berkeley president Robert Sproul to provide special scholarship funds to those Japanese Americans whose higher education was disrupted by internment. But he did not denounce racism itself, instead arguing that the white race was actually reproducing faster than people of other races, so that fears of being overwhelmed by nonwhite masses were not justified, although he had to acknowledge that this white-friendly ratio did not hold in the United States.

Taylor was cautious, but he was also an activist with a powerful sense of social responsibility. Despite Dorothea's photography assignment, she and Paul tried to get President Roosevelt to issue a message to Japanese Americans that Taylor drafted (a moment at which he undoubtedly overestimated his influence, but it was worth a try). Its language is eloquent, not at all typical of an economics professor, but quite typical of Lange-Taylor collaborations. For example,

> Your fellow-Americans of other ancestries, those who know you best, know you as law-abiding, self-reliant, hard-working, courteous neighbors. Most of you are under twenty-five years of age. All of you are products of the same public schools as ourselves. There you have learned the American language which you speak with

the same accents, yes, even the same slang of the playground, as ourselves. There you have imbibed the principles of democracy which this Nation cherishes as its heritage. . . . There is no charge against you. Our war is with the war lords who rule the Empire of Japan.

But it concluded,

War calls upon us all for sacrifice for our common country. In this strange way it has called upon you. I know that you so understand it. . . . In this spirit . . . I acknowledge your acceptance of evacuation as your contribution to the service of our common country in war.[39]

The WRA official to whom they sent it would not even show the letter to WRA head Milton Eisenhower, let alone to the President.[40]

Taylor had agreed with Paul Kellogg, the *Survey Graphic* editor, that the article appear in April, but postponed publication until September as he tried to get it approved in advance by the military censors. Moreover, he could see that Lange was on increasingly dodgy terms with internment authorities and wanted to prevent them from firing her. "Danger to the making of photograph record—the status of which, if not its existence, is in jeopardy," he wrote Kellogg.[41] Typically a reserved man given to quiet, understated expressions of his views, Taylor was unusually angry in his condemnation of the censorship he and Dorothea were experiencing: "The western idea of censorship, I'm told, is to keep the assembly center newspaper from telling the Japanese they can get the Tolan Committee report by writing to their Congressman . . . too much obstruction and heavy-handedness here. . . . Don't know what the 'censorship' your wire spoke of means in the East, but I've had excellent clues to what it means here. . . . Situation tight and tough here impossible to discuss situation . . . am therefore trying to draft analysis of basic factors less exciting but I hope helpful for the future."[42]

Suspecting that his letters were being read, Taylor gave few specific examples and wrote in euphemisms. "Reading between the lines of your letter," Kellogg wrote in one letter, and Taylor replied, "Your reading between the lines is correct. We've been, and are going through *something*."[43] By the time the article

was finished, he wrote privately that he had "sacrificed all [of the most damning evidence] . . . in hopes that I could ask people to look at the irreparable damage . . . damage internally, damage with our allies and potential allies, damage to our own children's and grandchildren's chance of survival. Maybe some editor's device, a box or something, not quoting me here . . . you will want to accent what seems to me so significant."[44]

Another limit on Lange's portrait of the internment came from her photographic technique. Her documentary photographs were almost always made outside in natural light. She rarely worked inside homes (except when invited by clients) because she was averse to entering people's private spaces, and also because she disliked the impact of flashbulbs on her subjects.[45] Roy Stryker, Lange's FSA boss, recalled that once she "was in a sharecropper's home; they had no light in there. Yet Russell [Lee, another FSA photographer] went in and flashed the damned thing, and got lousy pictures. They were lousy pictures, because the woman was sick. But [Dorothea wouldn't use a flash, explaining] 'even though we could hardly see what was going on in there because I didn't want to spoil that . . . I wouldn't dare; it would have been an insult to that woman; it would have been unfair to her.' Now with a better lens we could still have gotten some of that quality. . . . Your job as a photographer is to try to create as best you can that environment that was responsible for that woman who was sick: dark, dirty, dingy."[46] One result of this reticence was that—in sharp contrast to her work during the Depression—Lange made fewer pictures of women than of men in the camps, because the men were more often outside. In her photographs we get little sense of the interior of the units in which the interned people lived; we see little of their barrenness or of the improvements the residents made. One of the exceptions, the photograph of Mr. Konda and his daughter that we include in this volume (page 151), shows what the flashbulbs of the time did. He is flatter, less complex than most of her subjects, and not just because he is not looking at the camera; Lange produced many portraits in which her subjects look away without losing their aspect of thoughtfulness or inner tension. Mr. Konda looks, simply, depressed. Of course his depression is more than adequately explained by the cell in which he lives and the prison surrounding the cell and the humiliation surrounding it all, but Lange was not

typically satisfied with mere condemnation. She usually avoided expressing her convictions through creating the most painful images possible, preferring instead to picture the nub of human resilience that somehow survived even in oppressive contexts.

To Dorothea and Paul, like many in the Bay Area, the internment was wrong not only as a matter of principle—personal friends were being incarcerated. Dave Tatsuno, a department store owner, had been one of Taylor's students at Berkeley. At the end of 1944, as the Tatsunos were making plans for return, Dorothea wrote inviting them to "use our home as a hostel, or way station, or in any way you desire, and as suits your convenience. . . . Our home can be your headquarters at any time. House is big and arrangements are flexible . . . "[47] They didn't stay, but there is a film of the Tatsuno children climbing in Dorothea's favorite live oak tree in her backyard.[48] The Mochidas, a family of chrysanthemum growers, became Lange/Taylor friends through her photography and afterward attended public events honoring one or the other of them.[49] The Uchidas hired her privately to photograph a wedding, arranged hurriedly just before the roundup so that the engaged couple could be together during their captivity, and they and the Lange/Taylors remained in touch for many years afterward. In 1967, on the twenty-fifth anniversary of the evacuation, the Japanese American Citizens League gave awards to some of those who had struggled against this injustice, including Paul Taylor—though he said that he considered the award mainly for Dorothea, who died in 1965.[50]

Dave Tatsuno and father.

In this book, we have tried to create a photographic chronicle that would tell the story of the internment from the point of view of its victims, in a narrative stretching from the evacuation order to Manzanar. But

Lange could not photograph it this way, because the operation was proceeding at different rates in different parts of the West. In her first week on the project, after a brief tour of the registering of Japanese Americans in San Francisco and several towns to the east (San Leandro, Hayward, Stockton), she returned to San Francisco to document the removal already under way there and also drove to Centerville, where registration was just beginning. On April 9 she went with a Washington WRA bureaucrat to the Sacramento delta, where she interviewed and photographed Japanese American farmers and farmworkers. She showed the hurried last harvesting, the last load of laundry, the garage sales.[51] Probably acting with a double agenda—to show what the internment meant and to educate the WRA man—she designed pictures that demonstrated the economic and emotional cost to Japanese Americans forced to leave behind farms, businesses, homes, and friends. Forced to sell at extremely disadvantageous prices and to entrust productive and personal property to those who might be unequipped or unmotivated to maintain it—making themselves vulnerable to looting and embezzling—Japanese Americans suffered heavy economic losses, estimated at $400 million (or $4.7 billion in 2003 dollars).[52] Lange and Taylor believed that Associated Farmers, the organization of big commercial farm owners in California that had crushed farmworker union struggles so brutally in the 1930s, supported the internment because they stood to gain cheap purchase of Japanese-owned land.[53]

As in her earlier documentary work, Lange's interviews were often as revealing as her photographs. On April 28 in Byron she listened in on an argument in front of the Odd Fellows' hall:[54] a "Caucasian farmer representing a company was trying to get his workers to continue working in the asparagus fields until Saturday when they were scheduled to leave. The workers wanted to quit tonight in order to have time to get cleaned up, wash their clothes, etc." In the Sacramento delta she took four single-spaced typed pages of notes on interviews with owners of commercial farms regarding what the loss of Japanese American workers would mean. One man, part owner of a 1300-acre ranch (small by California standards), says he is completely dependent on an entirely Japanese American workforce and a Japanese American manager who supervises four Japanese American foremen. Another, who operates 6500 acres,

praises the Japanese workers and derogates both Mexicans and Okies as undependable. Another, operator of 1400 acres, says "You ought to let us keep at least our key men. We can't get along without them."

She spent most of April working in the Bay Area, mainly San Francisco, where processing and removal were large-scale undertakings. On May 2 she went to another assembly center, at Turlock, south of Modesto, and then returned to catch the initial removals from Byron. On May 5 she managed to photograph in the East Bay and also in Centerville, where she wanted to capture the Negi family handing over their ranch to others; the next day was back in Oakland, where the roundup was starting. On May 8 she managed both Hayward and Centerville. May 9 through 11 it was Centerville again, then Florin and Sacramento. And so it went as she tried to catch key developments as they happened. She made repeat visits to locations with much activity or good photographic opportunities. She was in Centerville on seven different days, not consecutive; she spent six days in Mountain View, three days each in San Jose and Mission San Jose, four days in Hayward. She worked on this punishing schedule into July.

Part of Lange's narrative strategy was to follow individuals through the internment process. She identified particular families, such as the Shibuyas of Mountain View, a town at the southern end of San Francisco Bay. She made individual portraits of each family member, showed them at work weeding, and photographed their upscale house and manicured garden as well as their commercial fields, which were as meticulously tended and as clear of weeds as their lawn. She photographed the daughters playing with their dog on the front lawn; the entire family posed in front of the white colonial-style house. The captions detail the achievements of the family. For example: "Mountain View, California. Ryohitsu Shibuya, successful chrysanthemum grower, who arrived in

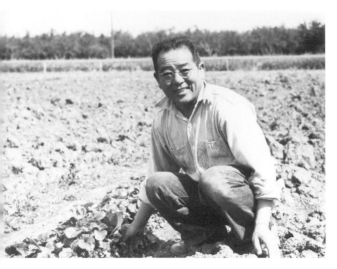

this country in 1904, with $60 and a basket of clothes, is shown above on his farm in Santa Clara County, before removal. He grew prize chrysanthemums for select eastern markets. Horticulturists and other evacuees of Japanese ancestry will be given opportunities to follow their callings at War Relocation Authority centers where they will spend the duration."[55]

Did she believe this last sentence? Or was she obligated to include it? Or by including it was she trying to hold the government to its promises? Lange repeated over and over in her captions the government's own language and promises about the internment. We have no evidence about her reasons for doing so, but at least one extrapolation seems justified: Lange probably calculated that the censors might look as much to the words as to the pictures and that she could appease them through captions. After all, the official justification was that the internment served to protect Japanese Americans, and government pronouncements frequently included praise for their hard work and achievements, so no one could object to photographs which showed precisely that.

Lange devoted hundreds of photographs to displaying the respectability, Americanism, work ethic, good citizenship, and achievements of these people now being treated as criminals.[56] The captioned photographs of the Shibuya family were part of this effort: "Six children in the family were born in the United States. The four older children attended leading California Universities."[57] "Madoka Shibuya, 25, was a student at Stanford Medical School when this picture was taken on April 18, 1942."[58] "Oldest son of the Shibuya family who graduated from the College of Agriculture, University of California, in 1939, with a degree in Plant Pathology."[59] She featured children reading American comic books, saluting the flag, playing baseball; housewives who could have been Betty

Crocker; teenage boys dressed oh-so-cool and young men in their army uniforms. This approach makes me uncomfortable because it seems to imply that these people were "deserving," as opposed to some unspecified others who might not be. It suggests that you have to earn human rights through good behavior. Lange did not make pictures of Japanese people who were unbeautiful or unconventional or down-and-out, and this self-censorship was characteristic of all her photography.

But it was more difficult for Lange to emphasize the upbeat when she began to photograph the roundup and the camps. We meet here a theme, both visual and emotional, that is to appear repeatedly through all her photographs of the internment: waiting in line. The Japanese Americans line up for their preliminary registration, they wait in chairs, they stand waiting before tables at which officials ask questions, fill out forms, give out instructions. Sometimes soldiers guard them. Now they are tagged: the head of each family received a number with a tag for each member of the family. Father is 107351A, mother 107351B, children C through F from oldest to youngest, grandmother 107351G, and so on. Then they wait for buses or trains to carry them away. Their scant belongings—they were allowed to take only what they could carry—also form queues on sidewalks and dirt roads. Lange is taking us into a brave new world of rationalization and control, featuring the industrial and technological forms of domination described most

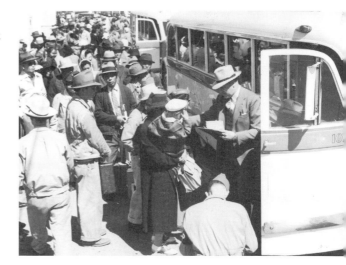

influentially by Michel Foucault. We see now that what is being stolen is not only farms and education and businesses and jobs but also personal identity. Individuals are registered, numbered, inoculated, tagged, categorized, and assigned. They are herded, segregated, exiled, inspected, billeted, surveilled. A curfew is imposed and roll call is held every day at 6:45 A.M. and 6:45 P.M.[60] A high barbed-wire fence surrounds them; in

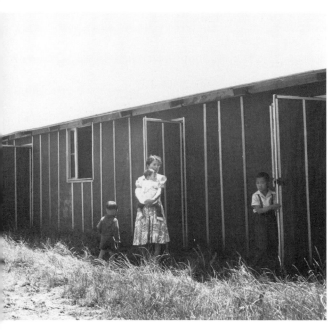

every direction they see armed guard and watchtowers; searchlights trace huge illuminated circles all night; camp police patrol day and night.

Since Lange was angry about the internment, once she took her camera into the camps she was more interested in documenting its inhumanity than in praising its victims. Gender was a primary dimension of this documentation, as it had been in her Depression photography. Her pictures identified particularly how domination and humiliation threatened masculinity, and how men of various generations and classes responded. That line of analysis appears less clearly among women, in large part because she made fewer pictures of women.

But despite being infuriated, the photographer mostly retains restraint and self-control, as do her subjects, and it is precisely this commitment to the discipline her craft requires that makes the photographs so compelling. She offers an occasional humorous observation, albeit drenched in irony. In a private notebook she wrote, "As an old man lines up his baggage for the inspection, an alarm clock begins to ring [somewhere inside his bundles]. . . . A young girl jumps off the bus in her brave new clothes all smiles, sees a friend up above, yells, 'Hi, how is it?' The other replies 'awful' and the smile fades . . ."[61] But occasionally the brutality of this ethnic cleansing, and the pain it caused, overwhelmed her. Lange's friend and assistant Christina Page recalled how once

> some Japanese farmer had driven his truck to town and a friend was going
> to take it back for him and his dog, a great big dog. . . . As the farmer got
> out of the truck and headed toward the train, the dog knew what was
> going on and the dog began to howl with a super-human, ungodly, just
> horrible screaming howl that was just the most heart-broken—it was just

an expression of the whole evacuation. . . . And can you imagine what it did to the owner of that dog? . . . And the MPs kept running around saying "Shut that dog up! Shut that dog up!" I mean nobody in that whole area could stand it. And finally the man that was supposed to drive the truck back to the farm couldn't stand it any longer and he didn't watch the train depart—he jumped in the truck and drove the dog off.[62]

On April 30 Lange went to the Tanforan Assembly Center in San Bruno, a former racetrack, and the next day, May 1, photographed the arrival of the first interned people. They passed through two lines of troops with rifles and fixed bayonets pointed at them, but Lange was not permitted to photograph this.[63] Each family received a broom, a mop, and a bucket because dust covered everything, but it returned within hours of being swept away. Each individual received a mattress tick bag, which he or she was to fill from a huge straw pile near the grandstand.[64] In the assembly centers the family "apartments" were typically single rooms with one window (although some were windowless), four to seven rooms in a "barrack," fourteen or so barracks to a block; each block had a mess hall, typically serving 800, laundry (although there were no washing machines, only tubs and washboards, and frequently no hot water) and ironing rooms, toilets and showers. Single men slept in a dormitory with 350 to 400 beds along each wall. As internee Miné Okubo put it, "They slept and snored, dressed and undressed, in one continuous public performance."[65] Although Tanforan rooms stank from their former use as stables and the walls between "apartments" were only horse-high, Tanforan was more comfortable than other camps, including some of the long-term concentration camps, because the stables were better insulated and because some were divided into two rooms by a swinging half-door—the rear room had housed the horse and the front room the fodder.[66] However, medical facilities were virtually nonexistent. While Lange and Page were at Tanforan, a pregnant woman in labor could not get permission to leave the camp for a hospital in San Bruno and gave birth on a wooden table, without stirrups, in a horse stall.[67]

Lange was clearly shocked by the accommodations, judging by the many photographs she made of them. Making her home beautiful, even artful, was one

of Lange's highest priorities, and she was aware of the same strong impulse in Japanese domestic culture. Lange also loved to make family holiday rituals. So she wanted us to see the innumerable antifamily deprivations and indignities of the camps: no privacy, no quiet, no family mealtime, no baths (only showers), no lawns, no automobiles; mess halls with assigned eating times for two shifts; group showers and crude latrines without partitions between seats, so that the lack of privacy led to widespread constipation.[68] She noticed the powerful peer culture among the children and the resulting decline of parental authority, a development offensive to many parents. Good manners eroded as meals were always hurried, reducing the ritual and elegance of Japanese cooking and serving to mere feeding of the body. Maintaining personal cleanliness was difficult due to chronic shortage of soap and hot water. Lack of insulation and ventilation made the cubbyholes in which they lived freezing in winter and sweltering in summer. No decent provision for washing diapers. Dust. Mud. Ugliness. Terrible food—definitely not Japanese—doled onto plates from large garbage cans. Nothing to do. Lines for breakfast, lines for lunch, lines for supper, lines for mail, lines for the canteen, lines for laundry tubs, lines for toilets. The most common activity is waiting.

Manzanar was the only long-term internment camp she was able to visit, because others were not yet open and because it was the only one to function both as a temporary assembly center and a permanent camp. The snow-covered Sierras looking down from the east did nothing to cool the 100-degree-plus heat, and there were neither trees nor hills to break the fierce winds, whether icy or hot. Lange was awed by its hostile environment: "meanest dust storms . . . and not a blade of grass. And the springs are so cruel; when those people arrived there they couldn't keep the tarpaper on the shacks."[69] Manzanar needed no high barbed-wire fence or guards—as with Alcatraz, geography formed the prison walls.

In this desert internees worked to create civilization and Lange photographed these accomplishments as best she could. They decorated their "apartments" with curtains, rugs, pictures, flowers, and room dividers. They made themselves partitions, shelves, closets, chairs, benches, and tables out of scrap lumber. They cleared the brush, irrigated and planted both vegetables and flowers. They built

libraries (although nothing written in Japanese was permitted), produced camp newspapers (whose contents were censored by the army), and put on talent shows. They created rock gardens and set up art classes in both Western and Japanese styles. They played Ping-Pong, volleyball, football, badminton, baseball, and basketball. They organized folk dancing. They conducted elections for representatives to camp councils, complete with ardent, contested

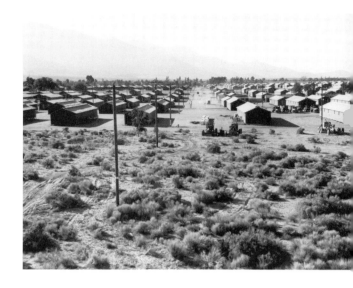

campaigning, although soon the army restricted voting to U.S. citizens. Later it abolished the councils altogether and added other restrictions: telephone use limited to emergencies and even then conducted under supervision, lights out at ten thirty, visiting privileges revocable at the discretion of the administration.[70]

The army installed two large-scale production projects, which Lange photographed intensively. At Manzanar and at the Santa Anita Assembly Center near Los Angeles, army engineers supervised manufacture of camouflage nets. Huge weavings of hemp, designed to fit over tanks and other large pieces of war matériel, they were constructed from cords that hung from giant stands; the workers usually wore masks to protect themselves from the hemp dust. The army claimed that they were volunteers but they were in fact coerced by camp administrators, who were receiving requisitions for large numbers of nets from the army. (One of the first strikes at the camps occurred when 800 Santa Anita camouflage-net workers sat down and refused to continue, complaining of too little food. They won some concessions.) At Manzanar other internees worked in a large agricultural project to grow and improve a plant, guayule, that could become a substitute for rubber. With rudimentary and often homemade equipment, chemists and horticulturalists hybridized guayule shrubs to obtain a substance of tensile strength with low production costs.[71] These undertakings

were illegal under the Geneva Convention, which forbade using prisoners of war in forced labor, and as a result only American citizens were usually employed so that the army could claim that these were not POWs.[72]

Ansel Adams photographed at Manzanar a year after Lange did, producing work that, by contrast, reveals much about Lange's perspective. He tried to walk a cramped line, opposing anti-Asian racism but avoiding identification with the opposition to the internment.[73] Adams's pictures, primarily portraits—surprisingly for a landscape photographer—emphasized the internees' stoic, polite, even cheerful "making-the-best-of-it."[74] His subjects were almost exclusively happy, smiling. His goal was to establish the internees as unthreatening, Americanized, open—scrutable rather than inscrutable.[75] By making mainly individual portraits, he masked collective racial discrimination. The resultant hiding of the internment's violation of human rights was not an unintended consequence of this goal, but an expression of Adams's patriotism. He believed that "the acrid splendor of the desert, ringed with towering mountains, has strengthened the spirit of the people of Manzanar. . . . The huge vistas and the stern realities of sun and wind and space symbolize the immensity and opportunity of America. . . ."[76] In November 1943 the Office of War Information asked him for permission to use his photos "showing American kindness to Japanese . . . urgently requested from our Pacific outposts to combat Japanese propaganda which claims our behavior is monstrous."[77] He was eager to comply, feeling badly that he was not doing more to contribute to the war effort. He was disappointed not to be able to enlist: he would have done so, he wrote, but was not offered a job appropriate to his skills, and could not "carry a gun to the Japs because they tell us we are over thirty-eight."[78] He told a friend, "The War Relocation Authority is doing a magnificent job, and is firm and ruthless in their definitions of true loyalty."[79] Before publishing his 1944 *Born Free and Equal*, he asked for advice and approval from Dillon Myer, director of the WRA, and later had Myer as a guest at his home in Carmel.[80] Adams later wrote, "It was obvious to me that the project could not be one of heavy reportage with repeated description of the obviously oppressive situation. With admirable strength of spirit, the Nisei rose above dependency. . . . This was the mood and character I determined to apply to the project."[81]

Ansel Adams did not invent this observation; this positive attitude did characterize many of the internees and their fortitude deserves honor, although it was also an attitude condemned by more militant internees. Lange and Christina Page also noticed the patience[82] of the internees, including even the children, and they also considered this a characteristic trait of the Japanese culture. Indeed, twenty years later Lange remained amazed at the lack of revengefulness on the part of some Japanese Americans she knew, such as Dave Tatsuno; "I don't understand those people," she said.[83]

Still, Adams's emphasis on this make-the-best-of-it approach, to the exclusion of so much else, was more damaging than constructive. It directed the eye away from conflicts and resistance in the camps, such as an open rebellion that broke out at Manzanar in December 1942, leading guards to kill two internees. It directed the eye away from the conditions under which the internees managed and away from the injustice of the whole enterprise. It also focused attention on what was most constructive and expedient in a situation where victims were isolated from outside political support, and when many Americans believed that the internment might hasten victory over the Axis powers. And it bolstered an interpretation widespread among both Japanese and non-Japanese Americans that if the internees passed this supreme test of their loyalty they would be rewarded with respect after the war. Not least, it extended and promoted a construction of people of Japanese ancestry as passive and compliant.

Some part of the differences between Lange and Adams came from the timing of their photographic work: by 1943, when Adams went, Manzanar was working better, and the internees had done far more to build their own culture. But more of the differences came from their political temperaments. Lange's willingness to defy her employer, to resist the authoritative decision of a president she so much admired, was completely in character. Just when the antifascist alliance of World War II transformed most social realist artists into Roosevelt loyalists, Lange took up a critical posture.

She did not give up easily. Her own pictures being sequestered, Lange wrote her friend Adams several times after his photographic trips to Manzanar, urging him to hurry and get his photographs to the public; her sense of responsibility to act overcame whatever resentments she might have felt about his greater clout

and respectability. She urged him to get them published immediately in newspapers, suggesting particularly the Sunday edition of *PM*, a liberal New York newspaper, and advised that he get in touch with Carey McWilliams for consultation on how to best disseminate the photographs.[84] It is not clear whether she had seen the photographs at this point, because twenty years later she was very hard on him, or at best patronizing:

> That's Ansel. He doesn't have much sense about these things. He was one of those
> at the beginning of the war who said—they'd had Japanese in their home always as
> house help and that was characteristic of his household—he said he saw the point.
> "You never get to know them," and all this. He gave the regular line, you know, but
> he wasn't vicious about it. He's ignorant on these matters. He isn't acutely aware of
> social change. It was far for *him* to go, far. He felt pretty proud of himself for being
> such a liberal . . . on that book. . . . He doesn't know how far short it is, not yet.[85]

Lange, by contrast, was angry and it showed. Ironically, she was the government employee, working under considerable constraint, while the Manzanar camp director gave Adams, a friend from the Sierra Club, freedom to come and go as he pleased over an eighteen-month period.[86] But the documentary style she had developed in the 1930s was inherently critical, and viscerally, emotionally so.

Yet Lange offered no images of resistance. Of course the army would not let her near any evidence of it, and she did her work so early in the development of the camps that resistance may not yet have developed. Christina Page thought that the closest they ever came to signs of resistance was in private conversations with people she knew well enough that they trusted her to keep their comments off the record.[87] Still, resistance was not her forte. In her 1930s work, photographs of strikes and demonstrations were never among her strongest.

Nevertheless, her portraits of people victimized were not simply portraits of victims. Their oppression did not reduce them or simplify their complexity. This was ultimately the essence of her portrait photography, to capture subtle and complex personalities and moods through showing people in moments of

reflection, in relationship to others, in their singular posture and gestural language. Her FSA work had honed her ability to compose pictures that showed context without reducing individuals to "types" and showed individuals without filtering out the situations that constrained them. Moreover, in her FSA work she could please her employers because they wanted above all to demonstrate not only the *need* for redistributive economic programs but equally the *deservingness* of those in need. Lange could do this so well because she knew how to construct her subjects as simultaneously needy but strong, oppressed but vital. Technically, ethically, emotionally, her transition from loyal bureaucrat to protester required no wrenching reorientation.

It must have been bitter for Lange to see these months of intense and passionate work remain undistributed, unpublished, seemingly erased. The work had been physically and emotionally draining, and represented a new direction politically and photographically.

Sequestering these photographs deprived not only their author but also Americans as a whole. To evaluate this loss, we need to consider the formative role of the visual in constructing the common understanding of the internment— and of all racisms and patriotic hysterias. World War II was so intensely and widely photographed that it became a proving ground for photojournalists, and their heroic or celebratory visual images have shaped our national memory of this "good war." Armed forces commanders themselves organized and trained enough photographers that each unit of each branch had at least one still and one cinema photographer.[88] Scores of movies, also in the heroic mode, have shifted this memory toward the sentimental at times. Whether raising the U.S. flag at Iwo Jima, holding a wounded GI buddy, or flying bombing runs from British bases, Americans were standing up against tyranny, saving the rest of the world from it.

Photography heavily influenced public opinion on these matters, and the Depression and World War II period represented a major leap upward in that influence. In fact, the construction of Japanese Americans as an internal enemy was itself partly a visual process. A demeaning caricature of the Japanese face was imprinted on the public through posters, graffiti, atrocity films, cartoons and caricatures. The epicanthic eye fold and prominent teeth in particular became

visual tropes for a despised, allegedly untrustworthy, and now enemy "race." The racist images were particularly authoritative to a public only just beginning to be saturated with photographic images: consider that *Life*, the first magazine to specialize in pictures, began in 1936 and had a circulation of 2 million within three years, and that advances in halftone reproduction geometrically multiplied the photographic material in newspapers. Given the long background of anti-Japanese racism on the West Coast, photography both intensified and reshaped racial categories, molding "Japanese" as a "visual field"[89] signifying disloyalty and treachery. Moreover, throughout the war years American news and entertainment media focused many times more on the war in the Pacific— against Japan, that is—than on the European war against our European enemies—whites, that is.

Of course it is a myth that race is something readily visible. The numerous signs identifying certain shops as Chinese and certain laboring groups as Filipino show the uncertainty of physiological categories, especially to outsiders' eyes. *Life* published two marked-up head shots supposedly teaching "Americans" how to tell the Japanese from the Chinese. But identification of who was "Japanese" according to legal status, as confirmed by paper documents, was entirely irrelevant. All those in the West with any Japanese ancestry at all, no matter how long resident in the United States and regardless of citizenship, were eventually incarcerated. The official registration of these "enemy" aliens and citizens—and about three-fifths to two-thirds were citizens—depended not on Immigration and Naturalization Service records but on the cooperation of the Census Bureau in providing the army with supposedly confidential population numbers and the outlines of Japanese neighborhoods.[90] Still, getting Japanese Americans to report and register without the army having to apprehend them in their homes depended on their similarity to widely circulated images; it reflected in part their understanding that they could not hide, that they could be identified and turned in by the "American citizens," i.e., the "white" citizens. Thus in World War II American nationalism became explicitly racialized.

Dorothea Lange challenged the political culture that categorized people of Japanese ancestry as disloyal, perfidious, and potentially traitorous, that stripped them of their citizenship and made them un-American. She would have

liked to stop the internment and, although she could not do that, she surely hoped that it would not be repeated. She was as eager to defeat the Axis powers as any other supporter of democracy, and worked on other photographic projects to honor those who contributed to the war effort—for example, in studies of defense industry workers. She too thought World War II was a "good war," honorable and necessary. If her photographs of a major American act of injustice had nuanced this verdict just a bit, that fact would hardly have undermined the national commitment. And the added nuance might well have contributed to developing among Americans a capacity for more complex, critical thinking about ensuing U.S. race and foreign policy.

NOTES

1. I have been unable to determine the legal basis and form of this suppression—that is, who made the decision, how it was decided and communicated, and under what authority. But my hunch is that in this wartime situation, army officials felt authorized to make many censorship decisions unilaterally. Governmental reluctance to use Lange's photographs continues now, well after the internment's wrong has been recognized and apologized for. For example, the National Park Service's Web site on Manzanar includes ninety-one photographs, of which eight are by Lange: none are among her most significant and only one is at all critical.

2. Out of 760 photographs that Lange made, the Conrats published 27, along with a variety of other photographs and some newspaper articles.

3. Carey McWilliams oral history transcript, "Honorable in All Things," Oral History Program, UCLA Library. Incidentally, the African American response was more divided. *Crisis*, the magazine of the NAACP, published a scathing denunciation of the internment: Harry Paxton Howard, "Americans in Concentration Camps," *Crisis* 49, no. 9 (Sept. 1942), 281–302.

4. It is online at http://www.uwm.edu/~margo/govstat/20213cs.jpg.

5. It is unclear when she quit using the name Nutzhorn, and what her motives were. She was certainly angry at her father, but it also bears notice that the name change was consistent with the widespread hostility to things German in the World War I era.

6. Tapes of KQED recording of Lange preparing 1966 MoMA exhibit, transcript, tape 3 p. 13, pp. 7–8, author's possession.

7. Historian David Gutiérrez is typical of today's scholars of Mexican Americans in his judgment that Taylor's works were "the most sensitive and penetrating studies of evolving Mexican American–Mexican immigrant relationships": Gutiérrez, *Walls and Mirrors: Mexican Americans, Mexican Immigrants, and the Politics of Ethnicity* (Berkeley: University of California Press, 1995), 64.

8. Lewis Hine had made serious photographs of urban working-class people, but he lacked Lange's transcendent skill as a portrait artist and his work never reached much beyond a constituency of social reformers.

9. Quoted in Naomi Rosenblum, "Documentary Photography: A Historical Survey," in *Changing Chicago: A Photodocumentary* (Urbana: University of Illinois Press, 1989), 8.

10. Lange to Minor White, May 2, 1961, in Oakland Museum photocopy books, volume IX.

11. Lange, interview by Suzanne Riess, 1968, "Dorothea Lange: The Making of a Documentary Photographer," transcript p. 181, University of California Regional Oral Office, Berkeley.

12. Wallace, "The Century of the Common Man," speech of 5/8/42, on line at http://www.winrock.org/wallacecenter/wallace/CCM.htm.

13. Nicholas Natanson, *The Black Image in the New Deal: The Politics of FSA Photography* (Knoxville: University of Tennessee Press, 1992).

14. Dorothea Lange to Roy Stryker 5/2/38, Stryker papers, Library of Congress.

15. *Personal Justice Denied: Report of the Commission on Wartime Relocation and Internment of Civilians* (Washington, D.C.: Government Printing Office, 1982), 6.

16. For the first two months of her work, Lange kept a daily record of her hours, destinations, and mileage. I could not discover whether she quit this reporting afterward because her employers had grown to trust her, or whether the reports for June and afterward were lost.

17. Paul Schuster Taylor oral history, Paul Schuster Taylor Papers, Bancroft Library, University of California/Berkeley, box 1, folder 13.

18. Interview with Christina Page Gardner, June 16, 2002; interview with Rondal and Betsy Partridge, March 21, 2002.

19. William John Schaefer, "A Study of Documentary Photographs of the Japanese-American Internment During WWII by Ansel Adams and Dorothea Lange," master's thesis, Scripps School of Journalism, Ohio University (2000), 79.

20. She added, "I learned that as a child in the Bowery. So none of these drunks' eyes would light on me." Riess, "Dorothea Lange," 16.

21. Henry Mayer interview with Caleb Foote, September 3, 1998, notes, author's possession.

22. Dorothea Lange to Dan Jones, July 13, 1964, John Dixon Collection [hereafter JDC] Papers; Riess, "Dorothea Lange," 189–94.

23. Gardner interview, June 16, 2002.

24. Riess, "Dorothea Lange," 191, 182–83, 189, quoted in Karin Becker Ohrn, *Dorothea Lange and the Documentary Tradition* (Baton Rouge: Louisiana State University Press, 1980), 141, and in Judith Fryer Davidov, " 'The Color of My Skin, the Shape of My Eyes': Photographs of the Japanese American Internment by Dorothea Lange, Ansel Adams, and Toyo Miyatake," *Yale Journal of Criticism* 9 #2, 1996, 226; Milton Meltzer, *Dorothea Lange: A Photographer's Life* (New York: Farrar, Straus and Giroux, 1978), 241–42, from his interview with Lawrence Hewes.

25. Riess, "Dorothea Lange," 189.

26. Interview with Thomas R. Bodine, who worked at the time for the American Friends Service Committee, by Karen Will, at http://vm.uconn.edu/~ww2oh/tb2.htm.

27. Caleb Foote to Al Hassler of Fellowship of Reconciliation, August 8, 1942, JDC Papers; U.S. House of Representatives, *Hearings Before the Select Committee Investigating National Defense Migration, Pursuant to H.Res. 113, part 29*, 77th Cong. 2d sess., 1942, p. 11804K; Henry Mayer, interview with Caleb Foote, September 3, 1998.

28. Gardner interview, June 16, 2002.

29. Telephone interview with Christina Gardner, July 9, 2004.

30. Riess, "Dorothea Lange," 189.

31. Paul Schuster Taylor oral history, Taylor Papers, 1:229, Bancroft Library, University of California/Berkeley.

32. It is important to keep in mind that in the 1940s there was no widespread awareness of how photographs could be doctored, but there was plenty of awareness of selectivity and point of view in photography.

33. Joy Rika Miyatake, "Toyo Miyatake," unpublished manuscript. I am grateful to Joy Rika Miyatake for giving me access to this.

34. Gardner attributed this to their "moxie." She defined this to me as "politically hip," but I suspect she was also thinking "brave." Gardner interview, June 16, 2002.

35. "Counselor" was the label given to Taylor by a staff member of the committee, a fact mentioned by Paul Kellogg to Taylor, May 2, 1942, in Taylor Papers.

36. I have corrected some obvious spelling errors in Taylor's handwritten letters, as here where he wrote "headlessness." Errors were very atypical for him and I suspect they reflected the stress and haste he was feeling.

37. Taylor to Paul Kellogg, n.d., labeled "confidential," Taylor Papers.
38. Paul S. Taylor, "Our Stakes in the Japanese Exodus," *Survey Graphic* 31, no. 9 (Sept. 1942), 575.
39. Taylor letter enclosed in M. M. Tozier of WRA to Dorothea Lange, May 21, 1942, copy in Oakland Museum, photocopy books, volume x.
40. Eisenhower held this position only a few months. He was succeeded by Dillon Myer.
41. Taylor to Paul Kellogg, June 15, 1942, labeled "confidential," Taylor Papers.
42. Letters and telegrams from Taylor to Kellogg, ibid.
43. Kellogg to Taylor, June 18, 1942, and Taylor to Kellogg, June 24, 1942, ibid.
44. Taylor to Kellogg, July 6, 1942, ibid.
45. Ben Shahn shared this distaste for flashbulbs: Howard Greenfeld, *Ben Shahn: An Artist's Life* (New York: Random House, 1998), 126; also see Richard Doud, interview with Shahn, transcript, p. 7, Archives of American Art.
46. Richard Doud, interview with Roy Stryker, III 15, ibid.
47. Lange to Dave Tatsuno, December 19, 1944, private collection of Dave M. Tatsuno, copy in author's possession.
48. Taylor oral history, Taylor Papers, 1:233.
49. Gardner interview, July 9, 2004.
50. Taylor oral history, Taylor Papers, 1:233.
51. Elena Tajima Creef, *Imaging Japanese America: The Visual Construction of Citizenship, Nation, and the Body* (New York: New York University Press, 2004), 40.
52. Lange of course could not know that the federal government would become directly responsible for this expropriation: for example, the U.S. Army bought Japanese Americans' cars for token prices; after the Federal Reserve Bank promised to store cars, evacuees turned over about two thousand, only to learn later in 1942 that their cars had been requisitioned by the army. See John Hersey, "A Mistake of Terrifically Horrible Proportions," in John Armor and Peter Wright, *Manzanar* (New York: Times Books, 1988), 6.
53. Gardner interview, July 2004. I have wondered about the fact that the director of the Manzanar camp, Ralph Palmer Merritt, was owner of Sun-Maid Raisins.
54. The International Order of Odd Fellows is a fraternal organization made up mostly of businessmen.
55. Caption to Lange photograph 537530, National Archives, Still Pictures Division, College Park, Md.
56. In this respect Ansel Adams's later photographs at Manzanar were similar.
57. Caption to photograph 536037, National Archives.
58. Caption to photograph 537475, ibid.
59. Caption to photograph 536430, ibid.
60. Miné Okubo, *Citizen 13660* (New York: Columbia University Press, 1946), 59.
61. Lange, typed notes, April 1942, Taylor Papers.
62. Doud interview with Gardner, p. 26.
63. Hersey, "Mistake of Terrifically," 7. In her brilliant illustrated book, *Citizen 13660*, Mine Okubo draws scenes like this from memory.
64. Okubo, *Citizen 13660*, preface.
65. Ibid., 63.
66. Dave M. Tatsuno to Professor Royal Roberts, June 16, 1942, Taylor Papers; Okubo, *Citizen 13660*, 35; Audrie Girdner and Anne Loftis, *The Great Betrayal: The Evacuation of the Japanese-Americans During World War II* (New York: Macmillan, 1969), esp. ch. 6.
67. Gardner interview, July 9, 2004. Although more than one hundred experienced midwives were among those incarcerated, the medical system in the camps would not employ them to assist in births, preferring to rely on inadequate numbers of doctors and nurses: Susan Smith, *Japanese American Midwives: Culture, Community, and Health Politics, 1880–1950* (Champaign: University of Illinois Press, 2005), ch. 5.

68. When the women complained that men were peering at them over the partition between men's and women's showers, a camp official responded, "Are you sure you women are not climbing the walls to look at the men?" (Hersey, "Mistake of Terrifically," 9).

69. Riess, "Dorothea Lange," 191.

70. Tatsuno to Roberts, June 16, 1942; Girdner and Loftis, *Great Betrayal*, ch. 7.

71. Guayule is the name of a shrub native to Mexico and Texas, found in sixteen species. The Manzanar project was the third of several attempts to use guayule as a rubber substitute, preceded by an "Emergency Rubber Project" during World War I and an effort by Continental Rubber in 1920. All failed, in that a cost-effective way to produce an adequate rubber substitute was not achieved. But in 1997 a patent was issued for a hypoallergenic latex made from guayule.

72. Girdner and Loftis, *Great Betrayal*, 181, 234.

73. Box 1, passim, Ansel Adams Papers, University of California at Los Angeles; Adams to Nancy Newhall, n.d. [1943], in Mary Street Alinder and Andrea Gray Stillman, eds., *Ansel Adams: Letters and Images 1916–1984* (Boston: Little Brown, 1988), 146–48.

74. Ansel Adams, *Born Free and Equal,* 2d ed., (Bishop, Calif.: Spotted Dog Press, 2001), passim.

75. Elena Tajima Creef points out Adams's disproportionate photography of young girls, as if he instinctively wanted to picture the least threatening internees; *Imaging Japanese America*, 21–22.

76. Adams, *Born Free and Equal*, 13. In his autobiography, which is more critical of the internment, Adams defensively apologizes for this statement; *Ansel Adams: An Autobiography* (Boston: Little Brown, 1988), 260.

77. Estelle Campbell to Ansel Adams, November 22, 1944, quoted by Nancy Newhall in an unpublished manuscript, Center for Creative Photography, Tucson, Ariz., 209.

78. Adams to Maynard Dixon, October 13, 1943, Maynard Dixon Papers, Bancroft Library, University of California/Berkeley. Oddly, in his autobiography, Adams blames his rejection on being forty-one and having dependents: *Ansel Adams*, 257.

79. Adams to Nancy Newhall, in Alinder and Stillman, *Ansel Adams*, 147. Adams had mixed feelings about some New Deal reforms in general: see Sally Stein, "On Location: The Placement (and Replacement) of California in 1930s Photography," in *Reading California: Art, Image, and Identity, 1900–2000*, ed. Stephanie Barron et al. (Los Angeles: University of California Press, 2000), 195, n. 19.

80. Dillon Myer to Adams, January 21, 1944, Adams to U.S. Camera Publishing, July 31, 1944, and Adams to Dillon Myer, October 5, 1944, all in Adams Papers, Box 2.

81. Adams, *Ansel Adams,* 260, quoted in Karin Higa and Tim B. Wride, "Manzanar Inside and Out: Photo Documentation of the Japanese Wartime Incarceration," in *Reading California: Art, Image, and Identity, 1900–2000*, eds. Stephanie Barron et al. (Los Angeles: University of California Press, 2000), p. 324. Adams wrote to Imogen Cunningham, "My main interest is to put over the idea to the sentimental man in the street (if there are any) and stay clear of the professional 'socially aware' crowd": Adams to Cunningham, n.d., in Imogen Cunningham Papers, Imogen Cunningham Trust, Berkeley, Calif.

82. In Japanese, *gaman*, or endurance.

83. Riess, "Dorothea Lange," 193.

84. Lange to Adams, November 12, 1943, and January 7, 1944, Adams Papers, Box 2.

85. Riess, "Dorothea Lange," 190–91.

86. Adams, *Ansel Adams*; Creef, *Imaging Japanese America*, 18.

87. Gardner letter to author, 7/04/2004.

88. This was true not only of American armed forces. Hitler delayed his march into the Polish city of Gdynia in order to allow cameramen to take up positions to photograph the assault troops: Michael Griffin, "The Great War Photographs: Constructing Myths of History and Photojournalism," in *Picturing the Past: Media, History and Photography*, eds. Bonnie Brennen and Hanno Hardt

(Urbana: University of Illinois, 1999), 124. Griffin cites Erik Barnouw, *Documentary: A History of the Non-Fiction Film* (New York: Oxford University Press, 1983), 139.

89. John C. Welchman, "Turning Japanese (in)," *Artforum International* 27 (April 1989), 152–56; Emily Medvec, introduction to *Born Free and Equal: An Exhibition of Ansel Adams Photographs* (Washington, D.C.: Echolight, 1984).

90. A small number of scholars have excavated buried discussions and agreements between the WRA and the U.S. Census Bureau about how to locate Japanese Americans, most of whom were at this time rural and not confined to "Japantowns." The Census Bureau violated aspects of its confidentiality promises to provide the information. See William Seltzer and Margo Anderson, "After Pearl Harbor: The Proper Use of Population Data in Time of War," paper at Population Association of America, March 2000, available at www.usm.edu/%7Emargo/govstat/newpaa.htm. Parallel discussions arise today about the contributions of the census to the post-9/11 roundup of Arab Americans: see William Seltzer and Margo Anderson, "NCES and the Patriot Act," paper at Joint Statistical Meetings, August 2002, and Lynnette Clementson, "Homeland Security Given Data on Arab-Americans," *New York Times* July 30, 2004, A10.

LOCATIONS OF INTERNMENT CAMPS

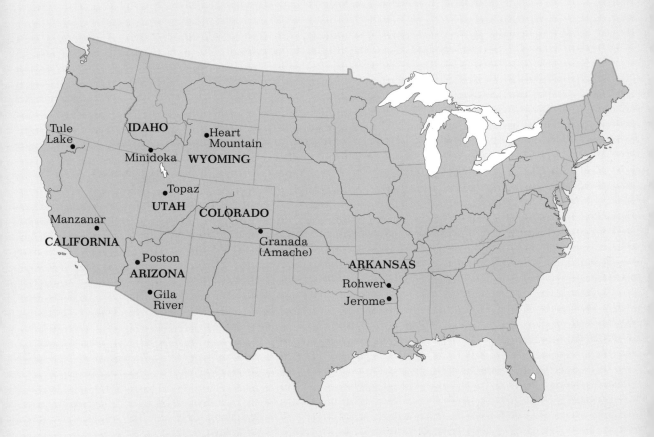

Tule Lake

IDAHO

Heart Mountain

Minidoka

WYOMING

Topaz

UTAH

COLORADO

Manzanar

CALIFORNIA

Granada (Amache)

Poston

ARIZONA

ARKANSAS

Rohwer

Jerome

Gila River

An American Story

GARY Y. OKIHIRO

"Listen my son," Ellen Kiskiyama wrote,
"now that you are older, Mother wants
you to understand why your only
friends are the sanseis [third-
generation Japanese Americans] and
why your only home is the barrack—
why you eat in the mess halls and why
you don't ride the street cars, buses
and automobiles." Pearl Harbor, she
explained, changed all "our plans," and

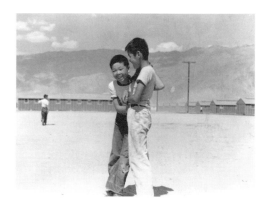

"little by little our home was broken up and all the fancy dreams we planned for
you had to be altered." Arthur, Kiskiyama's son, was born in the Pomona Assembly
Center before being scattered with his aunts, uncles, and cousins into U.S.
concentration camps—Manzanar, Poston, Gila River, and Minidoka, while his
uncle served in the U.S. Army. How was it possible that for these U.S. citizens
"each day rolled into weeks and weeks into months and months into years" in
concentration camps, despite the guarantees of life, liberty, and property?[1]

The story, in fact, begins in the mid-nineteenth century when the United States dispatched an armed flotilla to Japan "to drive by force," in the words of the expedition's leader, Commodore Matthew C. Perry, the overmatched Japanese into "opening" its doors to U.S. trade and influence.[2] That invasive entering wedge of U.S. military and commercial interests led to sweeping changes in Japan and to Japanese labor migrations to Hawai'i and the North American continent. The first government-contract recruits were brought to Hawai'i in 1868, and an additional 29,000 arrived between 1885 and 1894. About 125,000 came to the islands as "free migrants" from 1894 to 1908, when a Gentlemen's Agreement between Japan and the United States halted the further migration of male laborers. Women were a mere 9 percent of Hawai'i's Japanese in 1890, but they increased to 22 percent in 1900, 31 percent in 1910, and 41 percent by 1920. About 27,450 Japanese migrated to the U.S. continent between 1891 and 1900, and 42,457 between 1901 and 1907, along with about 38,000 who remigrated from Hawai'i to the mainland. Women constituted only 4 percent of the U.S. continental Japanese in 1900, but they rose to 13 percent in 1910 and 35 percent by 1920. Most of that increase was due to the migration of so-called picture brides, who escaped the restrictions of the Gentlemen's Agreement.

"The picture brides were full of ambition, expectation, and dreams," remembered Ai Miyasaki.[3] Those women (and later their children) joined men in a life of mainly field labor, although women worked in the household and field and moved seamlessly from unpaid to paid labor. On a typical workday on their California tomato farm, Kimiko Ono and her husband got up before sunrise and picked the day's harvest until about 6:30 A.M., when Ono stopped to prepare breakfast for the family. After eating, her husband left to sell the tomatoes, and she watered and tended the tomato plants in the greenhouse while trying to care for her three children. "Even when the children were tired of playing and fussed, I couldn't quit and go to them," Ono recalled sadly. "Meanwhile, the crying voices would stop, and many times I found my youngsters sleeping on the ground. Telling myself, 'Poor little things! When you grow up I will let you do whatever you want to do . . . only please forgive your mama now,' I worked continually." Ono's husband returned from the market about 7:00 P.M., and after dinner, she put the children to bed. She then sorted tomatoes and packed them

in boxes. Turning in at midnight was early, she recalled. A farmer and mother, Ono was also a poet, who described her life as "working . . . working."[4]

Originally welcomed, indeed recruited, for their labor, Japanese Americans posed a problem to their employers when they struck for higher wages and improved working conditions. Thus, in 1920, when some 8,300 Japanese, Filipino, Puerto Rican, and other sugar plantation workers on the island of Oʻahu demanded higher wages for men and women, an eight-hour day, paid maternity leave for women, and better health-care and recreational facilities, the planters cast that multiracial, democratic action as "an attempt on the part of the Japanese to obtain control of the sugar industry" and as "a dark conspiracy to Japanize this American territory." A federal commission sent to investigate Hawaiʻi's labor situation after the strike warned of the "menace of alien domination," and military intelligence concluded that Japan had embarked upon a race war by orchestrating its nationals abroad—notably, Buddhist and Shinto priests, Japanese-language schoolteachers, newspaper owners and editors, radical labor leaders, and pliant workers—to advance its imperial ambitions.[5]

The Bureau of Investigation, forerunner of the FBI, predicted a year after the 1920 strike that the rising tide of color would soon swamp "the white race" not only in California but also along the entire Pacific coast, and stated that "it was the determined purpose of Japan to amalgamate the entire colored races of the world against the Nordic or white race, with Japan at the head of the coalition, for the purpose of wrestling away the supremacy of the white race and placing such supremacy in the colored peoples under the dominion of Japan."[6] Such exaggerations, of course, matched the most lurid "yellow peril" fantasies being churned out for the public by journalists, writers, and filmmakers of the time with little basis in fact.[7]

The advance legions in that momentous clash, Japanese Americans, constituted a significant proportion of the population of Hawaiʻi, about 43 percent in 1920, but they totaled a mere 111,000 of some 106 million souls in the forty-eight states. And their reliance upon Japan to bolster their slender ranks was tenuous at best. For instance, in 1909, when the Higher Wages Association and some 7,000 Japanese American workers from all major Oʻahu plantations went on a four-month strike for full equality in the workplace, Japan's consul

general, as "a representative of the Japanese Emperor," urged the strikers to return to their jobs. He reprimanded them for damaging relations between employers and employees, and threatened that "those who do not heed his [the consul general's] advice," Japanese-language newspapers reported, were "being disloyal to the Emperor."[8] In truth, the strikers who disobeyed Japan's consul general were acting in a very American way in exercising their right to strike and demanding a living wage to support themselves and their children and to build communities and futures in the United States and not in Japan.

During the 1930s, U.S. intelligence expanded its surveillance network and refined its prescription for containing the alleged Japanese contagion. In the midst of those preparations, on August 10, 1936, President Franklin D. Roosevelt wrote an astonishing note to the military's Joint Board chief in Washington, D.C.: "Has the local Joint Planning Committee (Hawai'i) any recommendation to make? One obvious thought occurs to me—that every Japanese citizen or non-citizen on the Island of Oahu who meets these Japanese ships or has any connection with their officers or men should be secretly but definitely identified and his or her name placed on a special list of those who would be the first to be placed in a concentration camp in the event of trouble." The President's query and "obvious thought" had been prompted by an intelligence report from Hawai'i that discussed the arrival in Hawaiian waters of Japanese naval vessels and the entertainment of their officers and men by local Japanese Americans, all very legal and public events. But in the eyes of U.S. strategists and Roosevelt, those encounters held national security consequences largely because, as put by an FBI report, "it is said, and no doubt with considerable truth, that every Japanese in the United States who can read and write is a member of the Japanese intelligence system."[9] The President, not content to be caught unprepared, asked the Joint Board chief and the acting navy secretary, "What arrangements and plans have been made relative to concentration camps in the Hawaiian Islands for dangerous or undesirable aliens or citizens in the event of [a] national emergency?"[10]

In response, the acting secretary of war informed Roosevelt that the army had established a "service command" in Hawai'i, which linked the military with Territorial forces such as the National Guard, police, and other civilian

organizations for "the control of the civil population and the prevention of sabotage, of civil disturbances, or of local uprisings" of "potentially hostile Japanese." And, in a separate reply, the Joint Board reassured the President: "It is a routine matter for those responsible for military intelligence to maintain lists of suspects, who will normally be the first to be interned under the operation of the Joint Defense Plan, Hawaiian Theater, in the event of war." But it underscored the necessity for continued vigilance, and urged that the total resources of government, in addition to those of the army and navy, be pooled for a common effort against the anticipated danger. Intelligence, the board noted, "for years suspected espionage activities on the part of the indicated nation in the Pacific" and considered "the curbing of espionage activities in the Hawaiian area to be of the highest importance to the interests of national defense."[11]

While military and civilian intelligence disagreed over the potential for sabotage among Hawaiʻi's Japanese Americans, they both agreed that the people's loyalty to the United States could be coaxed by interning their leaders. Thus, on the eve of Pearl Harbor, both military intelligence and the FBI maintained lists of Japanese American "suspects" for their selective detention program. That strategy was especially important for Hawaiʻi, where Japanese American labor was essential for the Territory's economy, and where the military's concern thus was, as put by the army's chief planner, "to guarantee security to the islands and still maintain economic stability as well as adherence to the democratic principles of American government." Accordingly, the army rejected as impractical and ruinous of the islands' industries the mass removal and detention of Hawaiʻi's Japanese Americans, despite the President's insistence, seconded by his navy secretary, upon that course of action well into 1942.[12]

Instead, the military's plan for Hawaiʻi, at least since 1923, was martial law to ward against the imagined Japanese peril. Military rule was swift and sure and neatly bypassed "the democratic principles of American government"; it could impose its program of selective detention, as well as institute labor controls and restrictions over freedoms of speech, religion, and movement. In addition, its arbitrariness and seeming omnipotence were designed to inspire fear and thus

obedience from the targeted people. "Fear of severe punishment," an army document declared, "is the greatest deterrent to commission of crime." The account credited the military's firm resolve and detention program for the absence of subversion among the Territory's Japanese Americans. "It is certain," the author claimed, "that many persons who might have been tempted to give aid, support or comfort to our enemy were deterred from so doing by the severity and the promptness with which punishment was meted out by the Provost Courts operating under the martial-law regime." And in retrospect, perhaps to justify his surrender of civilian rule, Hawai'i's governor recalled that "internment of all suspected enemy aliens was the only safe course to put the 'fear of god' in the hearts of those who would assist the enemy."[13]

That "day of infamy," December 7, 1941, when Japan attacked Pearl Harbor, marked the end of an era and the beginning of another. A watershed in U.S. and Japanese history and in the relations between both nations, World War II was also a dividing line for Japanese Americans. As smoke still rose from the wreckage of America's Pacific Fleet, martial law was declared in Hawai'i, and squads of FBI agents, military police, and local law enforcement officers knocked on the doors of persons listed on index cards for apprehension in Hawai'i and on the West Coast. By December 9, 1,291 Japanese, 865 Germans, and 147 Italians were in custody in the islands and on the continent.[14]

Thus it was that in the conduct of a war waged for white supremacy, according to U.S. planners, against imperial Japan, some 120,000 Japanese Americans—two-thirds of whom were U.S. citizens (the remainder were prohibited from that citizenship by U.S. law)—were forcibly and summarily removed from their homes and placed in concentration camps for the duration of the war. They were not accused of any crime other than the presumed "fact" of their "race." One drop of "Japanese blood" justified that

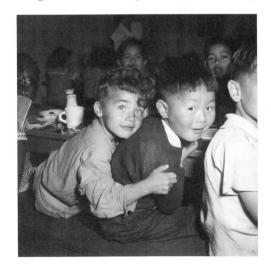

racial profiling, according to the U.S. government. As the general in charge of the defense of the West Coast explained: "The Japanese race is an enemy race and while many second and third generation Japanese born on United States soil, possessed of United States citizenship, have become 'Americanized,' the racial strains are undiluted." The *Los Angeles Times* added: "A viper is nonetheless a viper wherever the egg is hatched—so a Japanese-American, born of Japanese parents—grows up to be a Japanese, not an American."[15]

Yasutaro Soga, a newspaper publisher in Honolulu, recalled that the events of December 7 filled him with apprehension and dread. Instead of his usual kimono, Soga put on his suit and wore shoes. In the evening, there was the anticipated knock on the door. "There were three, taller than six feet and young, military police," remembered Soga. "They told me to come to the immigration office. Without hesitation, I replied, 'surely' and went to my bedroom to wear my vest and coat." His wife went with him outside to the gate, and, in farewell, she whispered in his ear, "'Don't catch a cold.' I wanted to say something," he confessed, "but the voice couldn't come out."

The familiar seemed foreign as he was driven through the blacked-out and deserted streets of his hometown. He entered a dimly lit room at the immigration station, where military police searched him and confiscated his personal items, and he was half-carried up a flight of stairs and pushed suddenly into a room and a disquieting darkness. "I didn't know how many people were kept in the room," Soga continued, "but I couldn't find an inch [of] space for myself to sit down." A kind hand guided the disoriented and stumbling old man to the top of a bunk bed, and there he sat listening to the muted voices in the gloom. At daybreak, Soga made out the rows of triple-decked beds and bed mats on the floor, and he counted sixty-four "brothers," many of whom he knew, crowded into that spare room.

The atmosphere in the immigration station was "bloodthirsty," Soga recalled; the guards exhibited "rough" attitudes toward their wards and "things could have burst into bloodshed once a false step was taken." For example, Soga explained, an arrogant, young white military policeman treated the internees, many of whom were elderly and distinguished, with obvious contempt by ordering them around brusquely with his pointed bayonet. "I was so furious,"

Soga admitted, "as if my blood started flowing backward. I almost threw my mess kit at him." A fellow Japanese American, Soga noticed, stared at the guard with "a pale face due to his anger," but they all had to restrain themselves because "if we had expressed our feelings, we would have died . . . a dog's death from the thrust of his bayonet."[16]

The treatment meted out to those men at Honolulu's immigration station was purposefully brutal, as if an extension of the old master-and-servant relations of the sugar plantations and in retribution for Japan's devastating attack on Pearl Harbor. And yet, the men, their captors knew, had not been selected because they had participated in the destruction of the U.S. Pacific Fleet. Rather, they received this special treatment of humiliation and abuse because they were leaders of the Japanese American community, and that lesson in power was intended to teach Japanese Americans that they were powerless, as confined leaders and as restricted members of the suspect "race." These "hostages," those responsible for the nation's security believed, would ensure the docility of the masses, summon their loyalty, and coerce their productive labor toward the winning of the Pacific war and, as they depicted it, the clash of empires and civilizations and the final triumph of white supremacy.

Twelve-year-old Donald Nakahata lived with his sister, mother and father, aunt, and grandfather in San Francisco. His father, a newspaperman, left for San Jose on December 7 or 8 to help Japanese Americans there. "And I walked him to the bus stop," remembered Nakahata. "We went down Pine Street down to Fillmore to the number 22 streetcar, and he took the 22 streetcar and went to the SP (Southern Pacific) and took the train to San Jose. And that was the last time I saw him." Nakahata's father was spirited away shortly thereafter, held at a detention station in San Francisco, and sent to several camps reserved for Japanese American leaders. "Dad was gone, and we just heard from him a little," said Nakahata sadly. "We have a few letters from him. And you know, I have no feeling if I look at them now. He apparently suffered several more strokes in various camps. But I know he was in Fort Sill, Oklahoma, and Camp Livingstone, Louisiana, and I think he died in Bismarck, North Dakota. It's really kind of sad if you think about it, that I don't know where he died."[17]

Yoshiaki Fukuda, a Konko church minister in San Francisco, was

apprehended on December 7. "Although we were not informed of our destination," Fukuda recalled, "it was rumored that we were heading for Missoula, Montana. There were many leaders of the Japanese community aboard our train. . . . The view outside was blocked by shades on the windows, and we were watched constantly by sentries with bayoneted rifles who stood on either end of the coach. The door to the lavatory was kept open in order to prevent our escape or suicide. A gloomy atmosphere prevailed on the train. Much of this was attributable to the fact that we had been forced to leave our families and jobs with little or no warning. In addition, there were fears that we were being taken to be executed."[18]

Like Fukuda, forty-five-year-old Ichiro Shimoda, a gardener from Los Angeles, was taken from his family on December 7. On the train to the Missoula detention camp, he attempted suicide by biting off his tongue. The other internees restrained him by putting a piece of wood between his jaws. Shimoda, a friend reported, worried over the fate of his wife and family back in Los Angeles, and was thus depressed. At Missoula, Shimoda tried to asphyxiate himself and, soon after he was transferred to Fort Sill in March 1942, he climbed the inner fence of the camp and was shot to death by a guard. According to the FBI report: "One Jap became mildly insane and was placed in the Fort Sill Army Hospital. [He] . . . attempted an escape on May 13, 1942 at 7:20 A.M. He climbed the first fence, ran down the runway between the fencing, one hundred feet and started to climb the second, when he was shot and killed by two shots, one entering the back of his head. The guard had given him several verbal warnings."[19]

A consequence of those arbitrary and swift removals and detentions was the fear anticipated by the architects of this program. In Seattle, Christian minister Daisuke Kitagawa remembered visiting the families of those who had been interned. "In no time," he wrote, "the whole community was thoroughly panic-stricken; every male lived in anticipation of arrest by the FBI, and every household endured each day in fear and trembling. Most Japanese, including at least one clergyman, were so afraid of being marked by association with those who had been taken away that they hesitated to visit the wives and children of the victims. Much of that fear can be attributed to the rumors, rampant in the community," Kitagawa reasoned, "about the grounds for those arrests, about the

treatment the detainees were getting, and about their probable imprisonment for the duration of the war. No rational explanation could set their minds at ease."[20]

Of course, word must have leaked out about the punishment inflicted upon the interned leaders. Across Honolulu harbor, within clear view of the immigration station, was Sand Island, a flat, desolate piece of land that at one time served as a place of quarantine for the thousands of migrants who landed in Hawai'i. Similar to the intentions of the health authorities, the army sought to quarantine the internees from the rest of Hawai'i's people by transforming the station into a concentration camp. Told they were "prisoners of war" by the camp commander, the internees were strip-searched, forced outside into the pouring rain, and in the gathering darkness ordered to erect the tents that housed them. Later, perhaps fearful that the "prisoners of war" might claim the protections of the Geneva Convention, the army modified its view by referring to the internees as "merely detainees."[21]

Sand Island's terror worked on both the body and mind. Strip searches were a common feature designed to peel off the outer defenses and expose the private parts. Citing that indignity, an internee exclaimed: "They stripped us down and even checked the anus. We were completely naked. Not even undershorts. They even checked our assholes." Another described how guards holding rifles lined a group up against a wall and threatened to shoot them if they refused to do as they were told. "With that threat," he remarked, "there was no need to say anything more." And the island was physically taxing. "A dust wind kept blowing almost every day in December," reported Yasutaro Soga, "and the night air was shivering cold." When it rained, the camp flooded, the tents leaked, and the cots, set on bare ground, frequently stood in huge pools of water. As a result, the internees' bedding, clothing, and supplies were constantly damp from the rain and daytime humidity. "The boss [camp commander] there made us, us men, really cry," recalled Kaetsu Furuya. "It was February and it was rainy—the rain would come down from the mountains and this boss would make us stand in the rain, practically naked, in our undershirt and underpants."[22]

One of those who stood in the rain that day was Kokubo Takara of Kaua'i. After about a month in a military prison in Wailua, where a one-gallon can

served as the men's toilet and where, because of the infestation, "we all got swollen faces from mosquito bites," Takara and twenty-six others were shipped to Honolulu's immigration station and from there to Sand Island. After having been forced to stand in the rain, Takara caught a cold, and was constipated for a week without any medication. "We had no medicine or means of helping him, so he died," lamented his friend Furuya. His body was returned to Kauaʻi for burial but because all of the island's Buddhist priests had been interned, there was no one to conduct the funeral service. A priest had to be released from Sand Island for that purpose, after which he returned to resume his detention.[23]

Women internees were kept separate from men and, unlike the men, were racially integrated. At least eighteen Japanese and about ten German and Italian women were interned on Sand Island. The camp commander's wife served as matron. Like the male internees, Japanese women were held because they were leaders who were often connected with Shintoism or Buddhism. But there were also women like Tsuta Yamane who was apparently interned because she defended her husband as he was being arrested, and Yoshiye Miyao and her daughter-in-law, Yuki Miyao, who signed their names "Y. Miyao"—because the authorities couldn't ascertain which Miyao posed a threat to the nation's security, they interned both. And there was Umeno Harada, wife of Yoshio Harada, who harbored a downed Japanese pilot after the Pearl Harbor attack and was killed, along with the pilot, upon their discovery. Harada was separated from her three young children, placed in solitary confinement, watched constantly by armed guards, and handcuffed whenever she was taken from her cell to the interrogation room. In protest, she refused to eat for five days. Her keepers summoned a minister to rekindle in her a desire to live. She eventually ended up on Sand Island.[24]

The FBI picked up Take Uchida and her husband, Setsuzo, in the early morning of December 8, 1941, in Idaho Falls, Idaho, because they were Japanese-language schoolteachers. "We were taken to the Seattle Immigration office immediately," she recalled. "We were not given a chance to store our belongings or furniture—just enough time to finish breakfast." From Seattle, her husband was sent to Bismarck, North Dakota, while Uchida remained in Seattle until April 1942, when she was transferred to the Federal Women's Penitentiary in

Seagoville, Texas. There she joined other Japanese American internees, women and children, and hostages from Peru, Panama, and Hawai'i. "Most of the ladies were schoolteachers and the educated wives of influential businessmen engaged in business with Japan," Uchida explained.[25] The South American Japanese were in U.S. internment camps mainly because of pressure from the American government, which intended to use them as hostages to exchange for U.S. prisoners of war in the Pacific theater.[26]

Those Japanese wives of internees who remained at home had to cope with maintaining households on their own. In Hawai'i, when Dan Nishikawa was taken away, Grace was left with a seven-year-old son, a frozen bank account, and unemployment, having been forced to leave her job. Without an income and with a son to support, Nishikawa sold all of her furniture and appliances at greatly reduced prices for money to buy food, and she "gave away" their entire hothouse of nearly 500 orchid plants, some costing as much as $125 each, for $25. She eventually had to leave her home because of poverty. Her health suffered from the strain of coping. "I became very ill," she said. "I went from one doctor to another, but they say there's nothing wrong. It's just nerves. I couldn't eat . . . it lasted for how many weeks, I don't remember. Even if I didn't eat for a few days, I just didn't get hungry. It was just like morning sickness; when you look at food, you just don't feel like eating."[27]

On Sand Island, amid the fear, suspicion, and abuse, Kaetsu Furuya observed, "Some of them [the internees] became neurotic and others became insane." Yasutaro Soga added, "I suspected that unless we were mentally strong, some of us would begin to have nervous breakdown[s]. . . . We were insecure and impatient." On February 17, 1942, two days before President Franklin D. Roosevelt signed the executive order that authorized the mass removal of all Japanese Americans along the West Coast, 172 Sand Island internees were told that they would be shipped to concentration camps on the mainland. Upon hearing that, Soga testified, most "no longer cared about their future because they were in despair," and even the strongest willed among them broke down and cried. Early on the morning of February 20, military trucks escorted by jeeps with machine gun mounts sped the internees through the back gate of the immigration station, past family members who had come to catch a glimpse of

their husbands, fathers, brothers, and sons. On board the *Ulysses Grant*, the internees were hustled belowdecks for the one-week voyage to Angel Island in San Francisco Bay.[28] That island, like Hawai'i's Sand Island, once served as a detention center for migrants "yearning to breathe free," mainly Chinese but also Japanese whose entry to the United States was restricted by racist exclusion laws.[29]

Throughout the spring and summer of 1942, Hawai'i's internees were scattered across the U.S. continent like the pink and yellow flower petals of the shower tree in a sudden gust of wind. When those winds subsided in 1946, traces of the islands' Japanese Americans could be found at Angel Island and Tule Lake (California), Camp McCoy (Wisconsin), Camp Forrest (Tennessee), Camp Livingstone (Louisiana), Camp Shelby (Mississippi), Fort Sill (Oklahoma), Fort Missoula (Montana), Lordsburg and Santa Fe (New Mexico), Crystal City and Seagoville (Texas), Jerome (Arkansas), and Topaz (Utah). Altogether, between 1942 and 1945, 1,875 Japanese Americans from Hawai'i made the crossing to concentration camps on the continent. An additional 1,466 Japanese Americans were held in camps in the islands. Those camps included Sand Island and Honouliuli on the island of O'ahu, but also prisons and special camps on the islands of Kaua'i, Maui, and Hawai'i. And under martial law, democracy fell victim to military rule throughout the Territory.[30]

As the nation prepared itself to defend democracy against the threat of fascism, its leaders authorized and conducted undemocratic actions that bypassed and ignored constitutional guarantees and freedoms. Not mere casualties of war and its hatreds, those violations long predated Japan's attack on that "loveliest fleet of islands," in Mark Twain's memorable words.

On the afternoon of February 11, 1942, the secretary of war, Henry L. Stimson, reportedly received from the President instructions to "go ahead and do anything you think necessary . . . if it involves citizens, we will take care of them too. He [the President] says there will probably be some repercussions, but it has got to be dictated by military necessity, but as he puts it, 'Be as reasonable as you can.'"[31] The fate, thus, of Japanese Americans on the continent was scripted by the fiction of "military necessity" and rested in the hands of the army and navy and in particular the army's Western Defense Command, headquartered in San

Francisco but extending from the northern border with Canada to the southern divide with Mexico. Indeed, on February 19, Roosevelt signed Executive Order 9066, which gave to the military power to designate areas from which "any and all persons may be excluded" and to provide for such persons "transportation, food, shelter, and other accommodations as may be necessary . . . to accomplish the purpose of this order."

Five days before EO 9066, Secretary of the Navy Frank Knox impatiently served eviction notices to Japanese American residents of Terminal Island in the port of Los Angeles, giving them a month to vacate their homes. The islanders, mainly fishermen and cannery workers, were prime targets because adjacent to their community was the Long Beach Naval Station and because the fishermen knew the coastal waters and had boats equipped with shortwave radios. Many of the men had been taken away in FBI sweeps shortly after Pearl Harbor during which, as described by Virginia Swanson, a Baptist missionary on the island, "the families huddled together sorrowing and weeping."[32] And contrary to the first directive, on February 25, suddenly and unexpectedly, the navy posted new notices, which ordered the Japanese Americans to vacate their homes within two days. "Near-panic swept the community," wrote Bill Hosokawa, "particularly those where the family head was in custody. Word spread quickly and human vultures in the guise of used-furniture dealers descended on the island. They drove up and down the streets in trucks offering $5 for a nearly new washing machine, $10 for refrigerators."[33] A nisei volunteer who helped the islanders pack recalled: "The women cried awful. . . . Some of them smashed their stuff, broke it up, right before the buyers' eyes because they offered such ridiculous prices."[34]

"The volunteers with trucks worked all night," Swanson reported. "The people had to go, ready or not. Some had to be pulled forcibly from their homes. They were afraid they were going to be handed over to a firing squad. Why should they have believed me," she asked, "telling them to get into trucks with strangers?" At the Forsyth School, one of the reception centers prepared by white and Japanese Americans, Esther Rhoads was among the volunteers. "All afternoon trucks and Japanese kept coming," she described the scene in a letter to her friend. "They were tired and dazed as a result of the sudden exodus. . . . We have old men over seventy—retired fishermen whom the FBI considered ineffective, and we have little children—one baby a year old . . . practically no men between thirty-five and sixty-five, as they all are interned. . . . Where are these people to go?" she asked poignantly. "There are many Japanese with young leaders able to face pioneer life, but those who have come to our hostels represent a group too old or too young to stand the rigors of beginning all over again."[35] And Terminal Island was just a dress rehearsal for the mass eviction and confinement program that would affect so many lives.

Assuredly, the 1942 government-sanctioned forced removals in Hawai'i and along the West Coast had precedents in U.S. history. There is, for example, President Andrew Jackson's particular hatred of American Indians and their resulting expulsion from the South, when thousands of Choctaws, Creeks, Chickasaws, and Cherokees walked and died along the Trail of Tears to the "Great American Desert" to settle on land deemed unfit for human habitation. Other deserts and barren lands, many on or bordering Indian reservations, awaited Japanese Americans some hundred years later. Dillon S. Myer, with his experience as director of the War Relocation Authority, the government bureaucracy that administered the World War II concentration camps for Japanese Americans, became the head of the Bureau of Indian Affairs, where he launched a program of Indian removal and assimilation called "termination."[36]

And other native peoples—for example, the Unangan or Aleuts—were, in the words of a U.S. government commission, "relocated to abandoned facilities in southeastern Alaska and exposed to a bitter climate and epidemics of disease without adequate protection or medical care," when the Japanese launched an attack on the Aleutian and Pribilof islands in the summer of 1942. There, "they

fell victim to an extraordinarily high death rate, losing many of the elders who sustained their culture." And while the U.S. government held the Aleuts in detention in southeastern Alaska, its military "pillaged and ransacked" their homes in the islands. Those forced removals, the commission concluded, along with the "slow and inconsiderate" resettlement thereafter, sadly followed the historical pattern of "official indifference which so many Native American groups have experienced. . . ."[37]

Like the government-sponsored removals of native peoples, the aggression against Japanese Americans required convincing democracy's constituents of the necessity and justification for the expulsions. Opinion polls traced the effectiveness of the government and media in manufacturing an anti-Japanese hysteria. A survey of Californians at the end of January 1942 found that 36 percent believed Japanese Americans to be "virtually all loyal," while 38 percent thought them to be "virtually all disloyal." Despite such divided opinion and an inability to distinguish the "loyal" from "disloyal," the majority of the survey's respondents held that the existing controls were adequate to ensure the nation's security, and only one-third called for more restrictions on Japanese Americans. The following month, after Roosevelt's signing of EO 9066 and after increased allegations of Japanese American treachery by some of the nation's leaders, fully 77 percent had come to dislike and distrust Japanese Americans on racial or national lines. And yet 54 percent still believed that government actions against them were adequate, although that number declined to 40 percent by the month's end. By March, a national survey found that 93 percent approved the internment of Japanese aliens, and 59 percent favored the removal of all Japanese, aliens and U.S. citizens alike.[38]

Government roundups and expulsions of Japanese Americans, combined with searches and seizures of "suspicious" items in their possession, including perfectly legal and innocent things such as radios, cameras, binoculars, and knives, helped to shape public attitudes. And Navy Secretary Knox's statement to the press in mid-December 1941 that Pearl Harbor was the result of "the most effective fifth column work that's come out of this war, except in Norway" directed suspicion at Japanese Americans and away from the failures of military intelligence and planning.[39] Similarly, on December 8, 1941, the *Los Angeles*

Times called for "alert, keen-eyed civilians" to guard against "spies, saboteurs and fifth columnists" because although "many" Japanese might be "good Americans," "treachery and double-dealing are major Japanese weapons." And the influential journalist Walter Lippmann warned of a "fifth column on the coast" and thus the "imminent danger of a combined attack from within and without."[40]

Still, not all of America's peoples believed or followed their leaders. The *San Francisco Chronicle*, for instance, a paper with a long history of anti-Japanese sentiments (having referred to migration as a "Japanese invasion" in February 1905), editorialized two days after the Pearl Harbor disaster: "The roundup of Japanese citizens in various parts of the country . . . is not a call for volunteer spy hunters to go into action. Neither is it a reason to lift an eyebrow at a Japanese, whether American-born or not. . . . There is no excuse to wound the sensibilities of any persons in America by showing suspicion or prejudice. That, if anything, is a help to fifth column spirit. An American-born Nazi would like nothing better than to set the dogs of prejudice on a first-class American Japanese."[41]

And religious groups, amid the apprehension of Japanese American leaders, issued calls for vigilance but also charity. On December 8, 1941, the presidents of the Federal Council of the Churches of Christ in America, the Foreign Missions Conference of North America, and the Home Missions Council of North America released a joint statement: "Under the strain of the moment, Americans will be tempted to express their resentment against the action of Japan's government by recriminations against the Japanese people who are in our midst," they wrote. "Let us remember that many of these people are loyal, patriotic American citizens and that others, though Japanese subjects, have been utterly opposed to their nation's acts against our nation. It is incumbent upon us to demonstrate a discipline which, while carefully observing the precautions necessary to national safety, has no place for vindictiveness."[42]

Whites, as church members and individuals, heeded the call for distinguishing between the enemy without and the neighbor within. In Seattle, whites called on homes to affirm their belief in the patriotism of interned men and their families, they tracked the whereabouts of the internees to reassure

their kin, and they assisted issei with frozen bank accounts and disrupted businesses. Race hatred had not trickled from the top down to all of America's people. Their faith in Japanese Americans and in the presumption of innocence unless proven guilty was vindicated by a comprehensive report by an army board of inquiry into the Pearl Harbor disaster. The board found that among Japanese Americans "no single instance of sabotage occurred . . . up to December 7," and "in no case was there any instance of misbehavior, despite a very exhaustive investigation being made constantly by the FBI, and by G-2 [army intelligence], as well as by Naval Intelligence."[43]

In March 1942, at a time when attitudes in the press and the government toward Japanese Americans became particularly virulent, Lieutenant General John L. De Witt, head of the army's Western Defense Command and in charge of implementing Roosevelt's executive order, issued proclamations that divided up the command into a "prohibited zone," essentially the coast and a strip along the Mexican border, and a "restricted zone," a larger area contiguous to the former. Although the restrictions also applied to German and Italian aliens, they were administered to "any person of Japanese Ancestry," who were advised to move "voluntarily" inland away from the "prohibited zone." Several thousand, perhaps as many as 9,000, Japanese Americans tried unsuccessfully to comply with the army's suggestion. "Those who attempted to cross into the interior states ran into all kinds of trouble," a government report noted. "Some were turned back by armed posses at the border of Nevada; others were clapped into jail and held overnight by panicky local peace officers; nearly all had difficulty in buying gasoline; many were greeted by 'No Japs Wanted' signs on the main streets of interior communities; and a few were threatened, or felt that they were threatened, with possibilities of

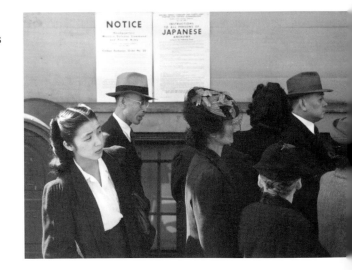

mob violence." The interior states refused to become California's "dumping ground."[44]

De Witt's first proclamations designated restricted zones, established a curfew for enemy aliens, and prohibited all Japanese Americans from leaving non-coastal parts of Washington, Oregon, California, and Arizona (the states where most of them on the continent lived), but they did not order any removals or confinement. On March 24, 1942, the general issued a "Civilian Exclusion Order" that differed from his earlier proclamations and became a model for all other exclusion orders that effected the complete removal of Japanese Americans from the West Coast. The target of his experiment were the several hundred Japanese Americans who farmed on Bainbridge Island in Puget Sound, near Seattle and at the approach to Bremerton Naval Yard. Soldiers dressed in battle fatigues tacked up the notices, "Instructions to All Persons of Japanese Ancestry," on the island's utility poles, at the post office, and at the ferry landing. The Bainbridge Japanese Americans, mostly berry and truck farmers, had six days to close their farms, settle their affairs, and pack their possessions.

Bill Hosokawa described the "raw, overcast day" of March 30. "Although the Japanese had been given less than a week in which to settle their affairs and pack," he wrote, "they began to gather at the assembly point long before the designated hour, each of the fifty-four families carrying only the meager items authorized by the Army—bedding, linens, toilet articles, extra clothing, enamel plates and eating utensils. All else, the possessions collected over a lifetime, had to be stored with friends, delivered to a government warehouse, sold or abandoned. Farms developed over decades were leased or simply left to be overgrown by weeds."[45] Armed soldiers directed the people onto a ferryboat, from which they viewed, some for the last time, their island home. In Seattle, a train took the islanders to California. "What impressed me most was their silence," wrote Thomas R. Bodine of the Bainbridge islanders as they boarded the train. "No one said anything. No one did anything."[46] The train creaked out of the station and headed south for Manzanar.

Following the Bainbridge precedent, the army and its civilian agency, the Wartime Civil Control Administration (WCCA) swept southward, forcibly evicting all Japanese Americans living in California and parts of Washington,

Oregon, and Arizona. By August 1942, the task was accomplished. "We were herded onto the train just like cattle and swine," recalled Misuyo Nakamura. "I do not recall much conversation between the Japanese." Tei Endow added, "Our departure was somewhat quiet and reserved. Everyone seemed willing to express good feelings rather than bitter ones. Naturally we did not like what was happening," she explained, "but we tried to suppress our feelings and leave quietly and with goodwill. . . . My five-year-old son thought it was great to ride on a train! But my husband and I commiserated with Mr. and Mrs. Tamura, crying together about our fate."[47]

"I cannot speak for others, but I myself felt resigned to do whatever we were told. I think the Japanese left in a very quiet mood, for we were powerless," explained Misuyo Nakamura. "We had to do what the government ordered." The night before their departure, Nakamura and other mothers must have wandered through the empty rooms of their houses, heard the deafening echo of their steps on bare floors, and felt the chill of remembrance. They must have looked back, as the car drove them off to the train depot, to catch a final glimpse of the verdant valley that was their home. "In my own mind, I thought, 'Surely we will be unable to return,' " Nakamura admitted. "I was so worried about what the future held for my children! We had struggled for many years, but we could lose everything. I was so frightened I actually did not think we would come home alive. . . . We took just one day at a time."[48]

Kathleen Shimada remembered the train ride to Pinedale Assembly Center. "All I can remember is its being so dirty and rattly, miserable and cold," she said. "Day wasn't bad, but at night we had to sleep in the chairs, just sitting with the blanket we had with us, frightened and depressed. The whole thing was just miserable. I was bitter then for being uprooted from my home and taken off. We didn't know where we were going. . . . The future is pretty bleak when you are uprooted from your home, not knowing where to go . . ." His vision blurred by tears, Shuji Kimura saw a lifetime of labor pass before his eyes. "The train began to go faster and the berry rows, the rhubarb, the lettuce fields, the pea fields began to slip past our window like a panorama," he recalled. "My throat hurt, but I couldn't take my eyes from the family fields and pastures slipping so quickly away."[49]

Although nearly all of them went quietly, a few Japanese Americans resisted their government's plans for them. In April 1942, before the eviction notices were posted, Mary Asaba Ventura, a nisei married to a Filipino American and a Seattle resident, locally challenged the military curfew orders that infringed unreasonably, she held, upon her rights as a loyal citizen. A federal judge denied her petition, trivializing her claim as "some technical right of [a] petitioning wife to defeat the military needs in this vital area during this extraordinary time." Another Seattle nisei, Gordon Hirabayashi, deliberately refused to comply with the curfew orders to test its constitutionality and failed to report for "evacuation." He was jailed for five months before his trial, where he was found guilty on both counts by the same judge who had heard the Ventura case. Hood River, Oregon, native Minoru Yasui, like Hirabayashi, purposefully violated the curfew order to challenge its legality, and was found guilty and sentenced to a year's imprisonment of which more than nine months were spent in solitary confinement. Fred Korematsu of Oakland, California, tried to avoid his forced removal and was found guilty of violating the military exclusion order. The U.S. Supreme Court eventually heard the *Hirabayashi*, *Yasui*, and *Korematsu* cases, and its judgments rendered against them formed the legal pillars that upheld the entire program of mass removal and detention.[50]

More than a violation of civil liberties, the government's actions sought to deny Japanese Americans their dignity and essential humanity. Registered and given numbers after waiting in long lines, the nameless were herded onto trucks, buses, and trains "like cattle and swine." They were dumped in makeshift "assembly centers," often county fairgrounds and horse racetracks, and made wards of their government, which arbitrarily stripped them of their rights and possessions, told them nothing about their destinations, and even denied them their futures. And they knew that their victimization was by virtue of their "race," deemed inferior and repugnant, and self-hatred and loathing might have been nurtured by that startling recognition. One's face and culture might have required, thus, denial and erasure. That was the heart of the matter for Japanese Americans in Hawai'i and on the U.S. continent.

The artist Mine Okubo and her brother were sent to the Tanforan racetrack in San Bruno, just south of San Francisco, after having been processed and

registered at the First Congregational Church in their hometown of Berkeley. "As a result of the interview," Okubo reported, "my family name was reduced to No. 13660. I was given several tags bearing the family number, and was then dismissed." The day of departure, Okubo wrote, "we took one last look at our happy home," and walked to join the faceless mass of people assembled at the Civil Control station. "Baggage was piled on the sidewalk the full length of the block," she noted. "Greyhound buses were lined alongside the curb." The ride across the Bay was quiet, a somber Okubo recalled, and upon arrival at Tanforan, the women and men were separated, and the men were stripped and searched "from head to toe" for contraband, including razors, knives, and liquor. After medical examinations, Okubo and her brother were assigned to barrack 16, room 50, which was in reality *stable* 16, *stall* 50. "We walked in and dropped our things inside the entrance," remembered Okubo. "The place was in semidarkness; light barely came through the dirty window on either side of the entrance. . . . The rear room had housed the horse and the front room the fodder. Both rooms showed signs of a hurried whitewashing. Spider webs, horse hair, and hay had been whitewashed with the walls. Huge spikes and nails stuck out all over the walls. A two-inch layer of dust covered the floor. . . ." Sitting in the semidarkness, Okubo wrote, "we heard someone crying in the next stall."[51]

"We went to the stable, Tanforan Assembly Center," Osuke Takizawa recalled. "It was terrible. The government moved the horses out and put us in. The stable stunk awfully. I felt miserable, but I couldn't do anything. It was like a prison, guards on duty all the time, and there was barbed wire all around us. We really worried about our future. I just gave up." His wife, Sadae, added, "Though I was tired, I couldn't sleep because of the bad smell. It was hell. Everybody felt lonely and anxious about the future. In a word, we were confused. Deep down we felt anger. It was a melancholy, complex feeling." Her husband admitted: "I was all mixed up. We couldn't do anything about the orders from the U.S. government. I just lived from day to day without any purpose. I felt empty. . . . I frittered away every day. I don't remember anything much. . . . I just felt vacant."[52]

The Pinedale Assembly Center near Fresno, called by the internees "Hell's Acre," was unbearably hot. Temperatures soared to 120 degrees in the shade. "It was a terribly hot place to live," Hatsumi Nishimoto recalled. "It was so hot that

when we put our hands on the bedstead, the paint would come off! To relieve the pressure of the heat, some people soaked sheets in water and hung them overhead." Others threw water on the concrete floor and lay there as the water evaporated. Besides the heat and tight and uncomfortable sleeping quarters, Tei Endow reported that there was no privacy in the barracks, which had flimsy or no walls, and in the toilets, which stood in a long

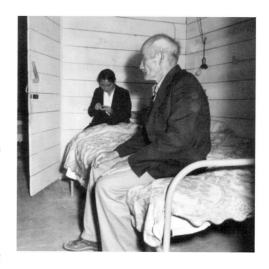

row without partitions. And the meals, remembered Miyoshi Noyori, often consisted of strange and unappetizing foods and combinations that left one hungry after eating. "Frequently our meal was a plateful of white beans, four or five fresh spinach leaves, a piece of bread, and sometimes a couple of wienies," she reported. "That was all we were served, so we had to eat it."[53]

Despite the centers' gloom, laughter could still be heard. Humor helped to ward off insanity, and served as an outlet for social commentary and criticism. "Yesterday," a young internee wrote imaginatively, "there was so much dust that ten feet up in the air I saw a mole digging his burrow." And in the horse stalls, residents held a fly-catching contest in which the winner proudly displayed a gallon jug filled with 2,462 dead flies. "How I wish we had traps or cats for the rats and mice who play tag all over us in the dark!" exclaimed a denizen of the Tanforan stables. Another reasoned, "We had to make friends with the wild creatures in the camp, especially the spiders, mice, and rats, because we were outnumbered." Internees at the Santa Anita racetrack vied for the "honor" of living in barrack 28, units 24 and 25, the stall once occupied by the famed horse Seabiscuit. And at Manzanar, residents put up signs naming their barracks Dusty Inn, Manzanar Mansion, Waldorf Astoria, and La Casa de Paz, while at Tanforan, artist Mine Okubo claimed she had "hoof and mouth disease" and thus tacked up a notice that warned, "Quarantined—Do Not Enter."[54]

"Humor," Okubo explained, "is the only thing that mellows life, shows life as

the circus it is. After being uprooted, everything seemed ridiculous, insane, and stupid. There we were in an unfinished camp, with snow and cold. The evacuees helped sheetrock the walls for warmth and built the barbed wire fence to fence themselves in. We had to sing 'God Bless America' many times with a flag. Guards all around with shot guns, you're not going to walk out. I mean . . . what could you do? So many crazy things happened in the camp. So the joke and humor I saw in the camp was not in a joyful sense, but ridiculous and insane. It was dealing with people and situations. . . . I tried to make the best of it, just adapt and adjust."[55]

To regain a measure of dignity, women pinned up curtains and propped up boards for privacy in the communal toilets, and despite knowing that Tanforan was a temporary shelter, volunteers planned a pond and park. They transplanted trees and shrubs around swampy ground that became a pond, and created islands and built a bridge and designed a promenade. When the park opened on August 2, 1942, "North Lake" "was a great joy to the residents and presented new material for the artists," a grateful Mine Okubo reported. "In the morning sunlight and at sunset it added great beauty to the bleak barracks."[56]

Those transformations, cited by U.S. government propagandists as evidence of the internees' gratitude for a "new beginning," testify instead to mourning and loss and recovery and resilience. Still, after some time at Pinedale, nine- or ten-year-old Louie Tomita looked up and said, "Pa, go home, go home. I like to go home." His father's hopeful, uncertain reply was, "I can't say nothing—maybe someday go home."[57]

From assembly centers like Puyallup (Washington), Portland (Oregon), Tanforan, Marysville, Sacramento, Stockton, Turlock, Merced, Salinas, Pinedale, Tulare, Santa Anita, and Pomona (California), and Camp Myer (Arizona), the "exiles" were "transplanted" to the ten concentration camps run by the successor to the WCCA, the War Relocation Authority (WRA): Tule Lake and Manzanar (California), Minidoka (Idaho), Topaz (Utah), Poston and Gila River (Arizona), Heart Mountain (Wyoming), Amache (Granada, Colorado), and Rohwer and Jerome (Arkansas).

Located some 200 miles north of Los Angeles, Manzanar, or "apple orchard," was named by the eighteenth-century Spanish invaders to the valley. Somber

gray mountains pushed upward by powerful tectonic forces rose from the valley floor to the west. That massive fracture in the earth's crust that formed the Sierra Nevadas could be traced from the tip of South America, up through Mexico and California, bending in an arc across Canada and Alaska, and down to the islands of Japan and the Philippines. That "ring of fire," a line of seismic and volcanic activity, borders the Pacific basin. Looking westward from Manzanar, the

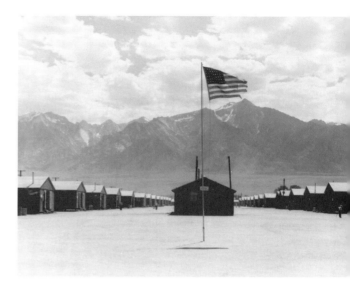

high, snowcapped Sierras might have reminded one of the mountains of Japan to which they were ultimately connected, but they also constituted a granite curtain that sealed off the valley from the freedom of the boundless sea.

The Sierras, topped by Mt. Whitney, dominated the visual and emotional landscape. One always felt the mountains' presence. And in the clear, desert sky, spread out over 560 acres, row upon row of flimsy tar-paper barracks, spare and drab, extended in straight lines that converged where the earth met the sky. "When we got to Manzanar," recalled Yuri Tateishi, "it was getting dark and we were given numbers first. We went to the mess hall, and I remember the first meal we were given in those tin plates and tin cups. It was canned wieners and canned spinach. It was all the food we had, and then after finishing that we were taken to our barracks. It was dark and trenches were here and there. You'd fall in and get up and finally got to the barracks. The floors were boarded, but they were about a quarter to a half inch apart, and the next morning you could see the ground below."[58] Haruko Niwa remembered, "The next morning, the first morning in Manzanar, when I woke up and saw what Manzanar looked like, I just cried. And then I saw the mountain, the high Sierra Mountain, just like my native country's mountain, and I just cried, that's all. I couldn't think about anything."[59]

It is difficult to come to the end of one's productive life and see the fruits of

that labor evaporate in the desert sun. But it is another grief altogether to contemplate stunted prospects for the tender, innocent transplants, the children, the next generation. Without the promise of spring, dreams can easily wither and die. For many, the act of creating restored a semblance of self-control and self-determination. Inscribing one's tracings upon the intractable earth helped to dispel the threatening darkness. Gardens transformed the desert into places of beauty. Even the hostile alkaline soil could not resist this labor of love. Using sticks, stones, and native trees, shrubs, cacti, and wildflowers, Japanese Americans landscaped their blocks and erected hedges and façades around their barracks to shield their dwellings from the dust storms and splash the pitiful tar-paper barracks and bleak surroundings with a mantle of color and life. "In some camps," wrote an observer, "hardly a stick or stone was available; nevertheless, the note of beauty had to be achieved, and *was* achieved, through the use of strings and vines. Morning-glories, pumpkin vines and gourds transformed hundreds of barren entrances into bowers of enchantment."[60]

Inside the barracks, internees transformed barren, cheerless cells into tidy homes. They put up walls where there were once only exposed two-by-four support frames, papered and painted them, carved out niches and added shelves, and built screens to cover the windows from the sun's glare. Using scrap lumber, including shipping crates, skilled hands built tables, chairs, dressers, and other furniture. "Papa spent most of his time in carpentry," recalled Asayo Noji. "He built a lot of furniture for our apartment, including a double-decker bed to save space, a heavy dresser with drawers, a lamp, and a folding screen decorated with carvings and a Japanese scene. . . . Papa gave away little tables and a lot of wooden vases—all shapes and sizes. He felt so much joy giving away his handcrafted goods!"[61] Creativity, it is important to remember, surged despite the paralysis of rejection and confinement.

The government rubbed salt in the open wound of racism by asking the excluded to prove their merit and worth by serving in the U.S. armed forces. "The army recruiting team came into Manzanar around the early part of 1943," Frank Chuman recalled. "We had a big meeting in this mess hall of all persons eligible for military duty with two white soldiers and a person of Japanese ancestry, and this guy was trying to persuade us all to volunteer for the army,

and I'm not too sure whether I got up and spoke back to him or whether I said it in my own mind, but I said, 'Why should we fight for the United States Government as soldiers, when the United States Government distrusts us? Why do they now want us to serve when they consider us to be disloyal? Why do they want us to serve when they have taken us out of our homes and schools and businesses? . . . It doesn't make sense, and so far as I'm concerned I'm not going to do anything . . . until the United States Government does something to remedy this unjust situation.'"[62]

The Fair Play Committee at Heart Mountain concentration camp, begun by Hawaiʻi-born Kiyoshi Okamoto to protest against injustices, attracted large and eager audiences after Secretary of War Stimson announced on January 20, 1944, that the nisei, formerly classed as "aliens not acceptable to the armed forces," would be subject to the draft. In a bulletin to the camp community, the committee declared: "We . . . are not afraid to go to war—we are not afraid to risk our lives for our country. We would gladly sacrifice our lives to protect and uphold the principles and ideals of our country as set forth in the Constitution and the Bill of Rights, for on its inviolability depends the freedom, liberty, justice, and protection of all people including Japanese-Americans and all other minority groups." Instead of those protections, the committee noted, "without any hearings, without due process of law . . . , without any charges filed against us, without any evidence of wrongdoing on our part, one hundred and ten thousand innocent people were kicked out of their homes, literally uprooted from where they have lived for the greater part of their lives, and herded like dangerous criminals into concentration camps with barb wire fencing and military police guarding it."[63] The committee's members thus refused to be drafted into the service.

To make an example of those draft resisters, the government charged sixty-three of them and seven members of the Fair Play Committee's executive council with draft evasion and conspiracy to violate the law. The trial judge, Blake Kennedy, addressed the defendants as "you Jap boys," and after finding the sixty-three guilty and sentencing them to three years' imprisonment, the judge assailed the men's loyalty: "If they are truly loyal American citizens," he wrote, "they should . . . embrace the opportunity to discharge the duties of citizens by offering themselves in the cause of our National defense." As for the

seven leaders, Kennedy found them all guilty and sentenced them to four years in Leavenworth Federal Penitentiary. After the war, an appeals court overturned those convictions, and on Christmas Eve 1947 President Harry Truman granted a presidential pardon to all draft resisters, including the nisei.[64]

Meanwhile, just as principled, patriotic, and heroic were nisei who volunteered and later were drafted to fight against fascism but also for their futures and those of their families. After Pearl Harbor, Hawai'i's military governor had dismissed 137 Japanese Americans who served in the Territorial Guard, while nisei soldiers in the National Guard were disarmed. Despite such treatment, those disallowed from the Territorial Guard formed themselves into a volunteer labor battalion called the Varsity Victory Volunteers to "set out to fight a twofold fight for tolerance and justice," in the words of a prominent member. In May 1942, the military governor endorsed the formation of a segregated unit of mainly Japanese Americans, and the next month, 1,432 men of the newly created Provisional Battalion set sail for the continent. In Oakland, they were hustled onto trains that took them into the interior, and at its destination, the train slowed and stopped. Peering out of the window and across the tracks, the men could see a concentration camp with barbed-wire fences and guard towers. "For half an hour we sat silently in our seats," said a nisei, "thinking only of the worst; many were pensive with grim and hollow faces." But the train moved to another corner of the base, Camp McCoy, Wisconsin, where the men trained to die for democracy in the shadow of an internment camp that held some of the leaders of their community.[65]

The men of the renamed 100th Infantry Battalion confronted other indignities before facing their country's enemies. They marched and trained with wooden guns until their commanders could trust them with firearms, white soldiers taunted them by calling them "Japs," and some of them were chosen to play the enemy on Cat Island, Mississippi. Because of the belief that "Japs" emitted a peculiar body odor that trained dogs could distinguish, nisei soldiers were ordered to hide in the island's cover and wait for the dogs to find them. "Most of us were transferred to Cat Island to pollute the island where the dogs were with the smell of 'Jap' blood," Yasuo Takata recalled. "Later results showed that this did not make any difference. . . . Each dog trainer sent his dog out to find us.

When the dog spotted us, the trainer would fire a shot and we would drop dead with a piece of meat . . . in front of our necks. The dog would eat the meat and lick our face. We didn't smell Japanese. We were Americans. Even a dog knew that!"[66]

In the end, about 26,000 Japanese American men and women served in the U.S. armed forces during World War II: in the 100th, composed mainly of men from Hawai'i; the 442nd Regimental Combat Team, composed of nisei from the concentration camps; those in the Military Intelligence Service and Office of Strategic Services, who fought in the Pacific war; and women who served in the Women's Army Corps. The 100th and 442nd were among the most decorated and most decimated units of the war, garnering 18,143 individual citations, and suffering casualty rates of 680 deaths and 67 missing. So remarkable was their valor on the battlefield that 9,486 received Purple Hearts.[67] "If you look at the 442nd boys," said Shig Doi, a veteran, "don't look at their faces, look at their bodies. Then you'll find out how much they've suffered."[68]

Of their sacrifice, President Truman told the thinned ranks of soldiers of the 100th and 442nd assembled on the White House lawn in 1946: "You fought for the free nations of the world . . . you fought not only the enemy, you fought prejudice—and you won. Keep up that fight . . . continue to win—make this great Republic stand for what the Constitution says it stands for: 'the welfare of all the people, all the time.' " Spark Matsunaga, veteran of the 100th and later U.S. senator from Hawai'i, elaborated upon that continuing struggle and its responsibilities: "If we the living, the beneficiaries of their sacrifice, are truly intent upon showing our gratitude, we must do more than gather together for speechmaking and perfunctory ceremonies. We must undertake to carry on the unfinished work which they so nobly advanced. The fight against prejudice is not confined to the battlefield, alone. It is still here and with us now." And, he concluded, "So long as a single member of our citizenry is denied the use of public facilities and denied the right to earn a decent living because, and solely because, of the color of his skin, we who 'fought against prejudice and won' ought not to sit idly by and tolerate the perpetuation of injustices."[69]

Indeed, even the gallantry of the nisei soldier failed to complete the "unfinished work"—to open the gates of the U.S. concentration camps or put an

end to racism. And it could not restore the losses sustained by a people judged guilty by reason of race. For how did the deaths of Ichiro Shimoda and James Wakasa, both shot and killed by guards at the fence, make the United States safe for democracy? Wakasa was a sixty-three-year-old issei bachelor who was shot by a sentry with a single bullet to the heart as he took his evening stroll at Topaz concentration camp.[70] Or how was justice served by the unnecessary death of an anonymous mother who, after giving birth, fell into a coma? She suffered for about ten days because of the poorly equipped camp hospital before her husband asked to put her out of her misery. "The doctor said we had nothing here to offer her," an attending nurse testified, "and if that's the wishes of the family, then he'll go along with it." And so the next day, the husband and four young children stood by their mother's bedside. "There was a teaspoon there with some water in it, and the father told each child to give the mother a sip of water, and after the last child gave the sip of water, the father did the same thing. . . . That was it. That was it. Right away the oxygen tent was removed and she just went to sleep." Haunted by that death, the nurse reflected years later, "But I still feel that if we were not in camp, that there might have been some other treatment."[71]

And what about the psychological impact of the concentration camps not only on those interned but also on their children?[72] What were some of those costs? Powerlessness, inferiority, and self-hatred became common responses, along with an imposed silence caused by a fear that it could happen again. Ben Takeshita recalled his feelings upon first learning about his older brother's ordeal at the Tule Lake camp, a long closeted family secret. Targeted as a troublemaker, he was held and questioned for three days, and "they got to a point where they said, 'Okay, we're going to take you out.' And it was obvious that he was going before a firing squad with MPs ready with rifles. He was asked if he wanted a cigarette; he said no. . . . You want a blindfold? . . . No. They said, 'Stand up here,' and they went as far as saying, 'Ready, aim, fire,' and pulling the trigger, but the rifles had no bullets. They just went click." Takeshita exclaimed, "I really got mad listening to it because the torture that he must have gone through. . . . I mean it's like the German camps. Torturing people for the sake of trying to get them to break down or something."[73]

Despite Truman's acknowledgment that racism was antidemocratic, an unrepentant government pursued the "repatriation" of Japanese Americans to a defeated and occupied Japan long after the war's end. San Francisco attorney Wayne M. Collins argued from 1945 to 1968 that the 5,766 Japanese Americans who renounced their U.S. citizenship during the war did so under duress and thus their action had no legal validity. "You can no more resign citizenship in time of war than you can resign from the human race," declared an indignant Collins about Public Law 405, an extraordinary measure passed by Congress in July 1944 to allow citizenship renunciation and supported by some who saw it as a way to rid the United States permanently of its "Japanese problem." Collins almost single-handedly managed to restore the U.S. citizenship of all but a few hundred.[74] Still, the fact that, as late as May 7, 1945, the House of Representatives passed a bill authorizing the "repatriation" of native-born women who had lost their U.S. citizenship by marrying aliens "ineligible to citizenship" (issei), and that the government sought "repatriation" over two decades after the war's end reveal a government determined to follow the same path of racism that justified the original violation of civil liberties.

And Japanese Americans remained in the concentration and internment camps long after Japan ceased to pose an invasion threat. Even after the war ended in August 1945, more than 44,000 were still in those camps. Although some Japanese Americans were gradually released during the war to work in vital industries, to serve in the military, and to attend colleges and universities, the last camp did not close until March 1946, when Tule Lake evicted its last internee. Mine Okubo remembered her departure from Topaz as "plowing through the red tape, through the madness of packing again," and attending seminars on "how to make friends" and "how to behave in the outside world." On the

day of her release, she received a train ticket as well as $25 plus $3 a day for meals while traveling, and a booklet, *When You Leave the Relocation Center*, courtesy of the WRA. The inestimable losses of a lifetime were thus reduced to a train ticket, an allowance, and instructions on how to act in a democracy.[75] "I looked at the crowd at the gate," continued Okubo. "Only the very old or very young were left. . . . I swallowed a lump in my throat as I waved good-by to them. . . . I relived momentarily the sorrows and the joys of my whole evacuation experience, until the barracks faded away into the distance. My thoughts shifted from the past to the future."[76]

Over President Truman's veto, the federal government passed in 1950 the Internal Security Act, which enabled the attorney general to apprehend and place in detention camps, without the rights of due process or trial by jury, any person suspected of "probably" engaging in espionage or sabotage. The act, passed at the onset of the Cold War, was intended to contain the menace of communism. One of the sponsors of the overall bill still objected to the provisions of the Title II section, calling it a program for "establishing concentration camps into which people might be put without benefit of trial, but merely by executive fiat . . . simply by an assumption, mind you, that an individual might be thinking about engaging in espionage or sabotage." Accordingly, from 1952 to 1957, when funding ended, the Justice Department maintained six concentration camps, including Tule Lake, which had held Japanese Americans just six years earlier. In 1960, three years after funds ran out but with Title II still in effect, the chairman of the House Committee on Un-American Activities resurrected the provision because "black militants have essentially declared war on the United States, and therefore they lose all constitutional rights and should be imprisoned in detention camps."[77] Alert to the injustice and danger of Title II, Japanese Americans, "as the past victims of American concentration camps," led a repeal effort, enjoined by African Americans and civil libertarians, which succeeded on September 1971.[78]

The Title II repeal effort was a part of the unfinished business of the World War II concentration camps, along with the redress and reparations campaign.[79] As noted astutely by Edison Uno, the Title II repeal campaign was an effort by the Japanese American community to come to terms with a shameful past by

acting as Americans with the full rights of citizenship. Japanese Americans, he declared, were held in "physical and psychological" concentration camps for too long. Furthermore, he added, that the internment provided Japanese Americans with a clearer sense of their place in the United States and gave them common ground with other oppressed minorities, including Native Americans who "for generations have been victims of the original American concentration camps which exist to this very day." And the social ills of poverty, hunger, disease, unemployment, mis-education, and racism "contribute towards the psychological concentration camps which continue to repress human beings as man practices his inhumanity to man. It is wrong to say 'it can't happen again,'" Uno predicted.[80]

Sadly, Edison Uno's warning has fallen upon deaf ears, and the past haunts the nation still. Prodded mainly by Japanese Americans, Congress belatedly passed the Civil Liberties Act of 1988, which issued a formal apology, as well as presidential pardons for those who had resisted the eviction and detention orders. At the same time, it provided recommendations that government agencies restore to Japanese American employees lost status or entitlements, and offered financial redress to Japanese American individuals—$20,000 to each survivor— and communities, and it created a community fund to educate the American public about the experience. The act's sponsors intended, through redress and education, to prevent racism from ever again justifying government infringements of civil liberties.

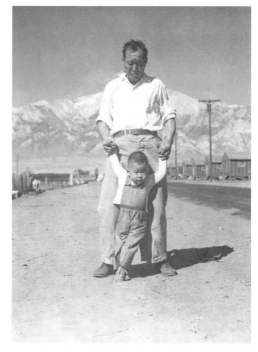

However, just thirteen years later, Congress passed the U.S.A. Patriot Act of 2001, under which racial and religious profiling enables a secret and

arbitrary government-sponsored program of registration, expulsion, and indefinite detention. Already there are some 5,000 detainees, according to an estimate, some of whom have spent nearly three years in prison, and not a single conviction has ever been won by the government.[81] And as before, empire is pursued on the basis of alleged threats to the nation's security, and protests against expansion abroad and lost liberties at home are rumored darkly to be unpatriotic and as giving comfort to the enemy.

"I am the wife of Albert Kurihara, who cannot be here today due to a stroke he suffered last week," Mary Kurihara explained to the presidential commission whose findings led to the passage of the Civil Liberties Act of 1988. "My husband is now in the hospital, but he still really wanted to testify. Albert has asked me to deliver his testimony." Kurihara was born in Hawai'i, and was sent to Santa Anita and Poston during the war. "I remember having to stay at the dirty horse stables at Santa Anita," he noted. "I remember thinking, 'Am I a human being? Why are we being treated like this?' Santa Anita stunk like hell." From Poston, he was "released" to do hard labor, "work which no one else wanted to do," and even after the war, "I was treated like an enemy by other Americans. They were hostile, and I had a very hard time finding any job. . . . This was the treatment they gave to an American citizen!" he exclaimed. "I think back about my younger brother, Dan, who was in the 442nd Regiment. In combat to defend his American native land, Dan suffered a bullet wound that damaged one-fourth of his head and caused him to lose an eye. I think back about what happened to my cousin, Joe. He was a World War I veteran and very proud to be an American. . . . Joe was never the same after camp. Once a very happy person, Joe became very bitter and very unhappy. . . . Every time I think about Dan or Joe, it makes me so angry. Sometimes I want to tell this government to go to hell. This government can never repay all the people who suffered. But, this should not be an excuse for token apologies. I hope this country will never forget what happened," Kurihara concluded, "and do what it can to make sure that future generations will never forget."[82]

NOTES

1. Carey McWilliams, *Prejudice: Japanese-Americans, Symbol of Racial Intolerance* (Boston: Little, Brown, 1944), 227–28.

2. William Heine, *With Perry to Japan*, trans. Frederic Trautmann (Honolulu: University of Hawaii Press, 1990), 3, 4.

3. Eileen Sunada Sarasohn, ed., *The Issei: Portrait of a Pioneer* (Palo Alto, Calif.: Pacific Books, 1983), 55.

4. Kazuo Ito, *Issei: A History of Japanese Immigrants in North America*, trans. Shinichiro Nakamura and Jean S. Gerard (Seattle: Japanese Community Service, 1973), 249–50.

5. Gary Y. Okihiro, *Cane Fires: The Anti-Japanese Movement in Hawaii, 1865–1945* (Philadelphia: Temple University Press, 1991), 70–81, 94–97, 100–101, 108–11.

6. Ibid., 116–17.

7. See, e.g., Roger Daniels, *The Politics of Prejudice* (New York: Atheneum, 1970), 65–78; and Gina Marchetti, *Romance and the "Yellow Peril": Race, Sex, and Discursive Strategies in Hollywood Fiction* (Berkeley: University of California Press, 1993).

8. Okihiro, *Cane Fires*, 51.

9. Ibid., 128.

10. Ibid., 173–74.

11. Ibid., 174–75.

12. Ibid., 183; and Roger Daniels, *Concentration Camps: North America, Japanese in the United States and Canada During World War II* (Malabar, Fla.: Robert E. Krieger, 1981), 72–73.

13. Okihiro, *Cane Fires*, 211–12.

14. Unlike Japanese Americans, Germans and Italians were not expelled and confined as an indiscriminate, "racialized" group. On the German and Italian internment, see John Christgau, *"Enemies": World War II Alien Internment* (Ames: Iowa State University Press, 1985); Stephen Fox, *The Unknown Internment: An Oral History of the Relocation of Italian Americans During World War II* (Boston: Twayne, 1990); and Lawrence DiStasi, ed., *Una Storia Segreta: The Secret History of Italian American Evacuation and Internment During World War II* (Berkeley: Heyday Books, 2001).

15. As quoted and cited in John Armor and Peter Wright, *Manzanar* (New York: Times Books, 1988), 38, 43–44.

16. Okihiro, *Cane Fires*, 212–13.

17. John Tateishi, *And Justice for All: An Oral History of the Japanese American Detention Camps* (New York: Random House, 1984), 32–35.

18. Yoshiaki Fukuda, *My Six Years of Internment: An Issei's Struggle for Justice* (San Francisco: Konko Church of San Francisco, 1990), 7–8.

19. Tetsuden Kashima, "American Mistreatment of Internees During World War II: Enemy Alien Japanese," in *Japanese Americans: From Relocation to Redress*, ed. Roger Daniels, Sandra C. Taylor, and Harry H. L. Kitano, rev. ed. (Seattle: University of Washington Press, 1991), 54.

20. Daisuke Kitagawa, *Issei and Nisei: The Internment Years* (New York: Seabury Press, 1967), 41.

21. Okihiro, *Cane Fires*, 215, 217.

22. Ibid., 217, 218.

23. Ibid., 218.

24. Ibid., 220–21.

25. Take Uchida, "An Issei Internee's Experiences," in Daniels et al., *Japanese Americans*, 31.

26. On Japanese Latina/os in U.S. internment camps, see C. Harvey Gardiner, *Pawns in a Triangle of Hate: The Peruvian Japanese and the United States* (Seattle: University of Washington Press, 1981); Seiichi Higashide, *Adios to Tears: The Memoirs of a Japanese-Peruvian Internee in U.S. Concentration Camps* (Honolulu: E&E Kudo, 1993); and Akemi Kikumura-Yano, ed., *Encyclopedia of Japanese Descendants in the Americas: An Illustrated History of the Nikkei* (Walnut Creek, Calif.: AltaMira Press, 2002).

27. Dorothy Ochiai Hazama and Jane Okamoto Komeiji, *Okage Sama De: The Japanese of Hawai'i* (Honolulu: Bess Press, 1986), 138.

28. Okihiro, *Cane Fires*, 216, 224.

29. See Him Mark Lai, Genny Lim, and Judy Yung, *Island: Poetry and History of Chinese Immigrants on Angel Island, 1910–1940* (Seattle: University of Washington Press, 1980).

30. Okihiro, *Cane Fires*, 267.

31. Daniels, *Concentration Camps*, 65.

32. Audrie Girdner and Anne Loftis, *The Great Betrayal: The Evacuation of the Japanese-Americans During World War II* (London: Macmillan, 1969), 112.

33. Bill Hosokawa, *Nisei: The Quiet Americans* (New York: William Morrow, 1969), 310.

34. Girdner and Loftis, *Great Betrayal*, 112–13.

35. Ibid., 113.

36. See Dillon S. Myer, *Uprooted Americans: The Japanese Americans and the War Relocation Authority During World War II* (Tucson: University of Arizona Press, 1971); and Richard Drinnon, *Keeper of Concentration Camps: Dillon S. Myer and American Racism* (Berkeley: University of California Press, 1987).

37. *Personal Justice Denied: Report of the Commission on Wartime Relocation and Internment of Civilians* (Washington, D.C.: Government Printing Office, 1982), 318–19.

38. Gary Y. Okihiro and Julie Sly, "The Press, Japanese Americans, and the Concentration Camps," *Phylon* 44, no. 1 (1983): 44, 78. A 1944 poll of *Negro Digest* readers found that 66 percent in the north and 53 percent in the south and west replied no to the question "Should negroes discriminate against Japanese?" *Negro Digest*, September 1944, 66.

39. Daniels, *Concentration Camps*, 35.

40. Ibid., 32, 68.

41. Quoted in Morton Grodzins, *Americans Betrayed: Politics and the Japanese Evacuation* (Chicago: University of Chicago Press, 1949), 380.

42. Toru Matsumoto, *Beyond Prejudice: A Story of the Church and Japanese Americans* (New York: Friendship Press, 1946), 10.

43. Okihiro, *Cane Fires*, 228.

44. Daniels, *Concentration Camps*, 83–84.

45. Hosokawa, *Nisei*, 308–9.

46. Girdner and Loftis, *Great Betrayal*, 134.

47. Linda Tamura, *The Hood River Issei: An Oral History of Japanese Settlers in Oregon's Hood River Valley* (Urbana: University of Illinois Press, 1993), 167–68.

48. Ibid., 169.

49. Girdner and Loftis, *Great Betrayal*, 139–40, 142.

50. See, especially, Peter Irons, *Justice at War: The Story of the Japanese American Internment* (New York: Oxford University Press, 1983).

51. Mine Okubo, *Citizen 13660* (New York: Columbia University Press, 1946), 18–19, 24, 26, 30–31, 33–34, 35–36.

52. Sarasohn, *Issei*, 183–84.

53. Tamura, *Hood River Issei*, 173–76.

54. Girdner and Loftis, *Great Betrayal*, 148, 152, 153; Okubo, *Citizen 13660*, 68; Tamura, *Hood River Issei*, 177; and Yoshiko Uchida, *Desert Exile: The Uprooting of a Japanese-American Family* (Seattle: University of Washington Press, 1982), 96.

55. Deborah Gesensway and Mindy Roseman, *Beyond Words: Images from America's Concentration Camps* (Ithaca, N.Y.: Cornell University Press, 1987), 71.

56. Okubo, *Citizen 13660*, 74, 98–99.

57. Tamura, *Hood River Issei*, 176.

58. Tateishi, *And Justice for All*, 24–25.

59. Ibid., 29.

60. Allen H. Eaton, *Beauty Behind Barbed Wire: The Arts of the Japanese in Our War Relocation Camps* (New York: Harper & Brothers, 1952), 52.

61. Tamura, *Hood River Issei*, 187; and Eaton, *Beauty Behind Barbed Wire*, 36–37, 54–55.

62. Tateishi, *And Justice for All*, 230–31.

63. Frank Seishi Emi, "Draft Resistance at the Heart Mountain Concentration Camp and the Fair Play Committee," in *Frontiers of Asian American Studies: Writing, Research, and Commentary*, ed. Gail M. Nomura et al. (Pullman: Washington State University Press, 1989), 43–44.

64. For a full account of the nisei draft resisters, see Eric L. Muller, *Free to Die for Their Country: The Story of the Japanese American Draft Resisters in World War II* (Chicago: University of Chicago Press, 2001).

65. Okihiro, *Cane Fires*, 255.

66. Ibid., 255–56.

67. Chester Tanaka, *Go for Broke: A Pictorial History of the Japanese American 100th Infantry Battalion and the 442nd Regimental Combat Team* (Richmond, Calif.: Go for Broke, Inc., 1982), 112, 143, 146.

68. Tateishi, *And Justice for All*, 161.

69. Tanaka, *Go for Broke*, 167, 170–71.

70. Sandra C. Taylor, *Jewel of the Desert: Japanese American Internment at Topaz* (Berkeley: University of California Press, 1993), 136–46.

71. Tateishi, *And Justice for All*, 149–50.

72. See Donna K. Nagata, *Legacy of Injustice: Exploring the Cross-Generational Impact of the Japanese American Internment* (New York: Plenum Press, 1993); and Stephen S. Fugita and Marilyn Fernandez, *Altered Lives, Enduring Community: Japanese Americans Remember Their World War II Incarceration* (Seattle: University of Washington Press, 2004).

73. Tateishi, *And Justice for All*, 247.

74. Girdner and Loftis, *Great Betrayal*, 441–49.

75. On the economic losses sustained by Japanese Americans, see Frank S. Arnold, Michael C. Barth, and Gilah Langner, *Economic Losses of Ethnic Japanese as a Result of Exclusion and Detention, 1942–1946* (n.p.: ICF Incorporated, 1983).

76. Okubo, *Citizen 13660*, 207–9.

77. Frank F. Chuman, *The Bamboo People: The Law and Japanese-Americans* (Del Mar, Calif.: Publishers, Inc., 1976), 327–29.

78. See Raymond Okamura, Robert Takasugi, Hiroshi Kanno, and Edison Uno, "Campaign to Repeal the Emergency Detention Act," *Amerasia Journal* 2, no. 2 (Fall 1974): 71–111.

79. On the redress and reparations movement, which culminated with a government apology and

monetary compensation, see *Personal Justice Denied*; William Minoru Hohri, *Repairing America: An Account of the Movement for Japanese-American Redress* (Pullman: Washington State University Press, 1984); Yasuko I. Takezawa, *Breaking the Silence: Redress and Japanese American Ethnicity* (Ithaca, N.Y.: Cornell University Press, 1995); Mitchell T. Maki, Harry H. L. Kitano, and S. Megan Berthold, *Achieving the Impossible Dream: How Japanese Americans Obtained Redress* (Urbana: University of Illinois Press, 1999); and Robert Sadamu Shimabukuro, *Born in Seattle: The Campaign for Japanese American Redress* (Seattle: University of Washington Press, 2001). For the experience in Canada, see Ad Hoc Committee for Japanese Canadian Redress, ed., *Japanese Canadian Redress: The Toronto Story* (Toronto: HpF Press, 2000).

80. Edison Uno, "Therapeutic and Educational Benefits (a Commentary)," *Amerasia Journal* 2, no. 2 (Fall 1974): 111.

81. David Cole, "Ashcroft: 0 for 5,000," *The Nation*, October 4, 2004, 6, 20.

82. Albert Kurihara, "The Commission on Wartime Relocation and Internment of Civilians: Selected Testimonies from the Los Angeles and San Francisco Hearings," *Amerasia Journal* 8, no. 2 (Fall/Winter 1981): 63–64.

CHAPTER 1

BEFORE THE EVACUATION

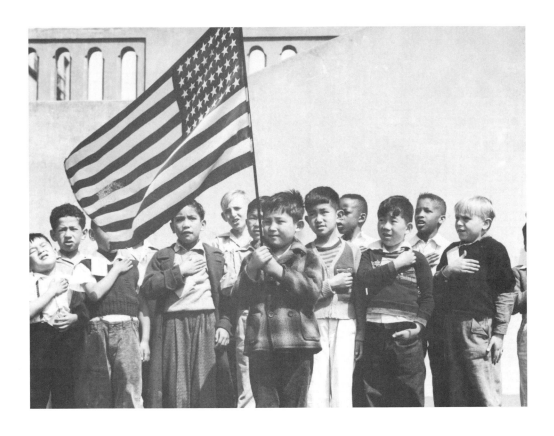

San Francisco, California. Flag of allegiance pledge at Raphael
Weill Public School, Geary and Buchanan Streets. Children in
families of Japanese ancestry were evacuated with their parents
and will be housed for the duration in War Relocation Authority
centers where facilities will be provided for them to continue their
education.

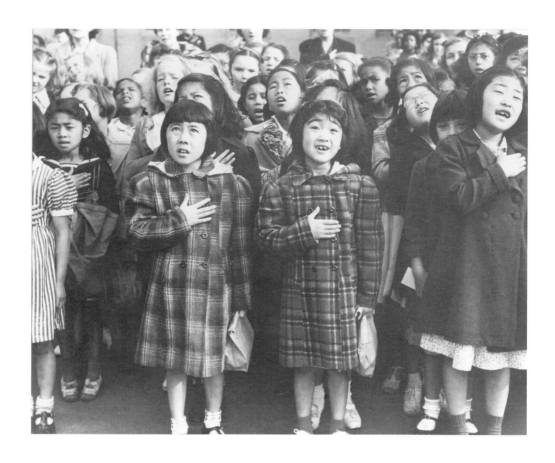

San Francisco, California. Flag of allegiance pledge at Raphael
Weill Public School.

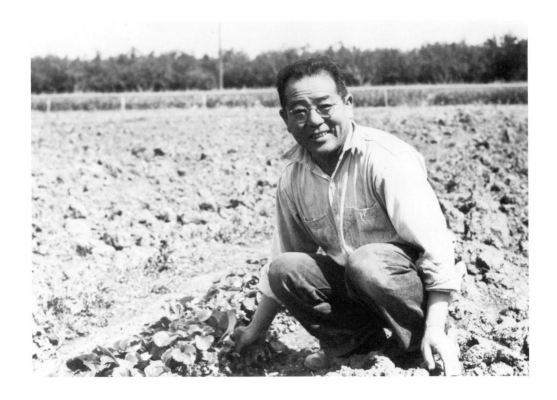

Mountain View, California. Ryohitsu Shibuya, successful chrysanthemum grower, who arrived in this country in 1904, with $60 and a basket of clothes, is shown above on his farm in Santa Clara County, before evacuation. He grew prize chrysanthemums for select eastern markets. Horticulturists and other evacuees of Japanese ancestry will be given opportunities to follow their callings at War Relocation Authority centers where they will spend the duration.

Florin, Sacramento County, California. A soldier and his mother in a strawberry field. The soldier, age 23, volunteered July 10, 1941, and is stationed at Camp Leonard Wood, Missouri. He was furloughed to help his mother and family prepare for their evacuation. He is the youngest of six children, two of them volunteers in the U. S. Army. The mother, age 53, came from Japan 37 years ago. Her husband died 31 years ago, leaving her to raise six children. She worked in a strawberry basket factory until last year when her children leased three acres of strawberries "so she wouldn't have to work for somebody else." The family is Buddhist. This is her youngest son. Her second son is in the army stationed at Ft. Bliss. 453 families are to be evacuated from this area.

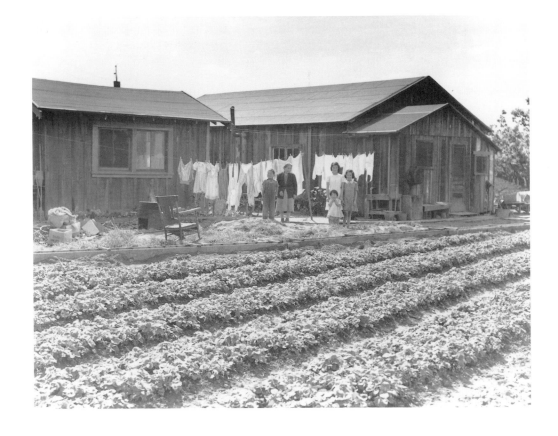

Mountain View, California. This ranch house, seen across a strawberry bed, is typical in many California rural sections where residents of Japanese ancestry engaged in truck gardening. This was the home of eight children who were born in this country. The parents were born in Japan.

Near Stockton, California. Field laborer of Japanese ancestry on a large-scale corporation ranch a few days prior to evacuation. These laborers earned from $750.00 to $1000 per year, plus living accommodations and their own little gardens.

Sacramento, California. College students of Japanese ancestry who
have been evacuated from Sacramento to the Assembly Center.

San Francisco, California.

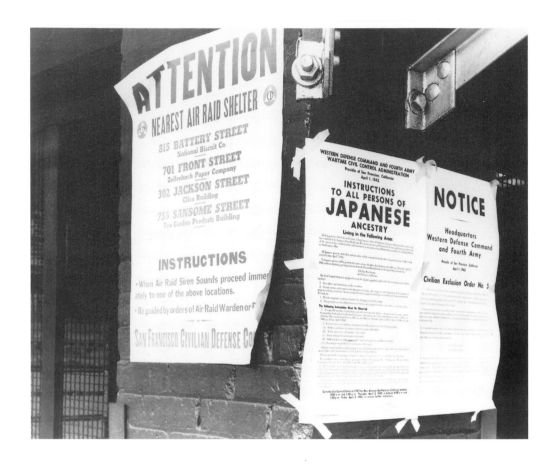

San Francisco, California. On a brick wall beside air raid shelter poster, exclusion orders were posted at First and Front Streets directing removal of persons of Japanese ancestry from the first San Francisco section to be affected by evacuation. The order was issued April 1, 1942, by Lieutenant General J. L. DeWitt, and directed evacuation from this section by noon on April 7, 1942.

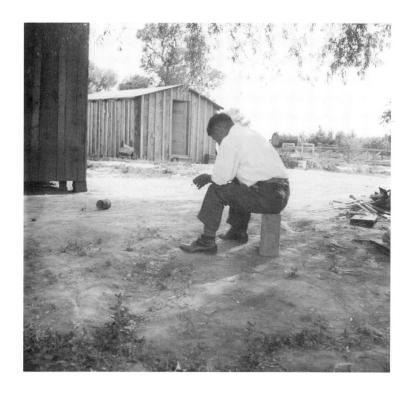

Woodland, California. Tenant farmer of Japanese ancestry who has just completed settlement of their affairs and everything is packed ready for evacuation on the following morning to an assembly center.

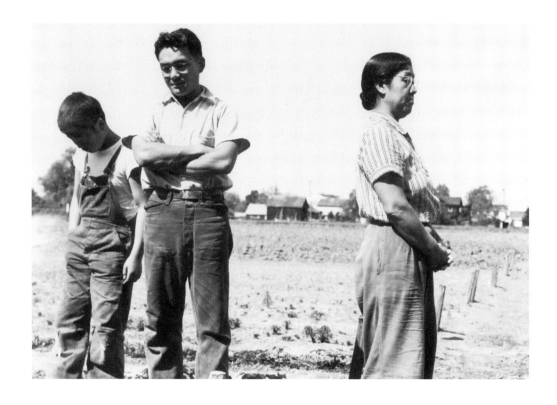

Mountain View, California. Mother and oldest son of the Shibuya family have been weeding in their 20-acre chrysanthemum farm prior to evacuation order affecting persons of Japanese ancestry in this district. The son is a graduate of the College of Agriculture, University of California, in plant pathology.

Centerville, California. Hands of woman farmworker preparing
soil for transplanting tomato plants, in a field in Alameda County,
several weeks before evacuation.

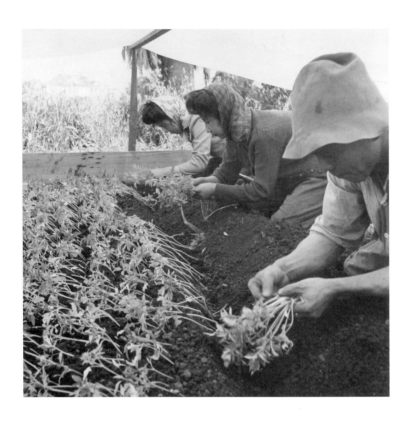

San Leandro, California. Family labor transplanting young tomato
plants under canvas about ten days prior to evacuation of residents
of Japanese ancestry to Assembly Centers.

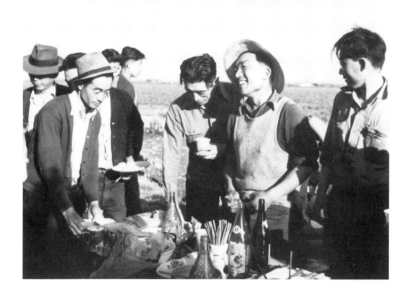

Mountain View, California. A pre-evacuation barbecue on a farm in
Santa Clara County.

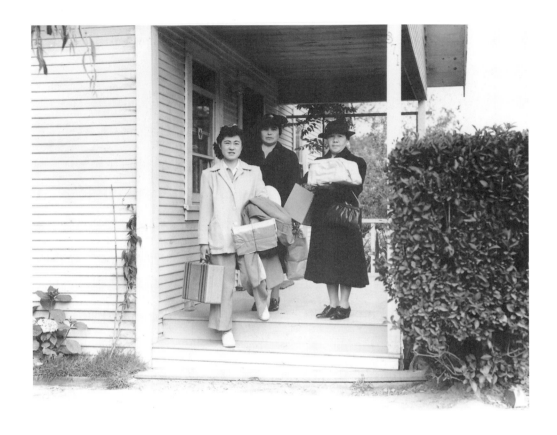

Centerville, California. Members of farming families are pictured
as they left for Centerville, one mile away, to board evacuation bus.
These women worked at so-called "stoop labor," chiefly cultivating
tomatoes. Farmers and other evacuees of Japanese ancestry will be
given opportunities to follow their callings at War Relocation
Authority centers.

Centerville, California. Yugoslavian farmer is taking over berry
farm formerly operated by residents of Japanese ancestry, who are
being sent to assembly points and later to be housed in War
Relocation Authority centers for the duration.

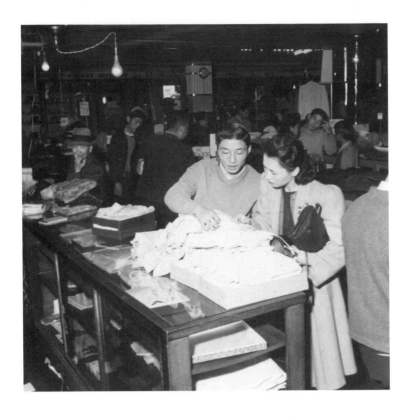

San Francisco, California. At a close-out sale these patrons were
buying merchandise to take with them when they are evacuated.

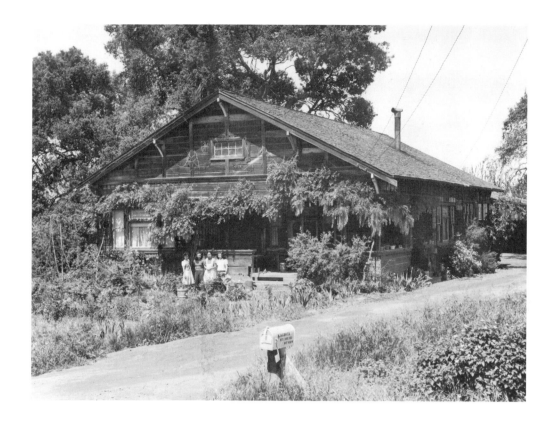

Mountain View, California, April 1942. A farm house
in the rural section where farmers of Japanese ancestry raised
truck garden crops.

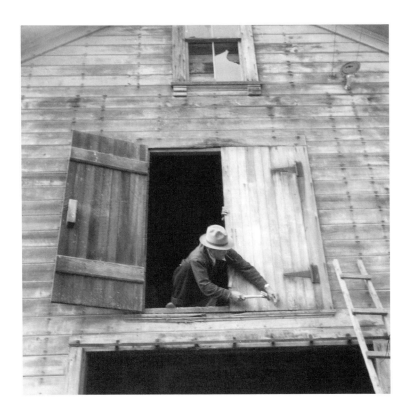

Centerville, California. Nailing the hayloft door on the morning of evacuation.

Florin, California. Hands of Reverend Naito (Buddhist priest) as he locks the door of his church. The beads are carried by Buddhist priests at all times.

San Francisco, California. With the owner scheduled to be
evacuated, a store front is boarded on Post Street.

Woodland, California. Household goods belonging to evacuees of
Japanese ancestry, stacked for storage. The Federal Reserve Bank
is assisting, in conjunction with the Wartime Civil Control
Administration, in the final settlement of their affairs.

San Francisco, California. Entrance to a restaurant vacated by a proprietor of Japanese descent prior to evacuation.

San Lorenzo, California. Wash-day 40 hours before evacuation of
persons of Japanese ancestry from this farming community in
Santa Clara County.

San Francisco, California. Lunch hour at the Raphael Weill Public School.

CHAPTER 2

THE ROUNDUP

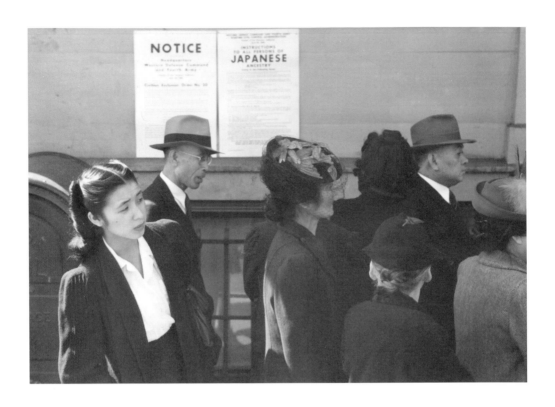

San Francisco, California, April 1942. Residents of Japanese
ancestry registering for evacuation and housing, later, in War
Relocation Authority centers for the duration of the war.

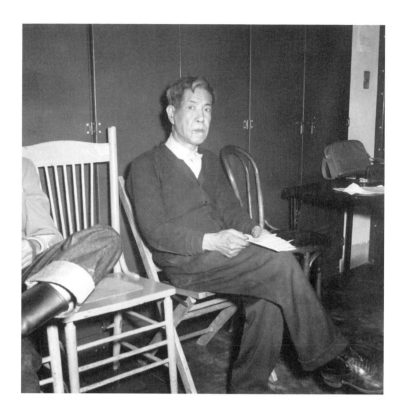

Hayward, California, April 1942. A farmer of Japanese ancestry at the Wartime Civil Control Administration station, preparatory to evacuation and going to a War Relocation Authority center for the duration of the war.

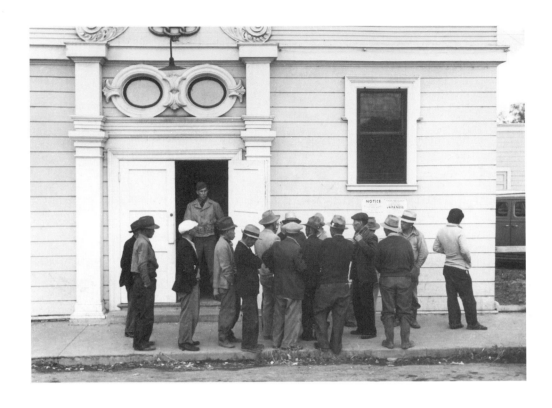

Byron, California. Field laborers of Japanese ancestry from a large [Sacramento River] delta ranch have assembled at Wartime Civil Control Administration station to receive instructions for evacuation which is to be effective in three days. They are arguing about whether or not they should return to the ranch to work for the remaining days or whether they shall spend that time on their personal affairs.

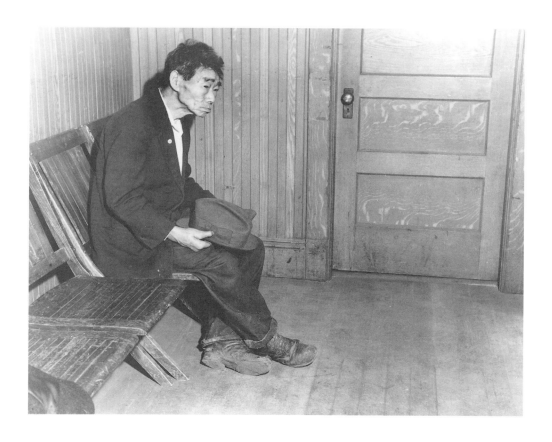

Byron, California. Toshi Mizoguchi waiting at the WCCA station to
register for evacuation. Mr. Mizoguchi came to the United States
from Japan in 1892 and has been a farm laborer on California
ranches since that time. He is unmarried. He is seen wearing an
American flag printed on a celluloid button.

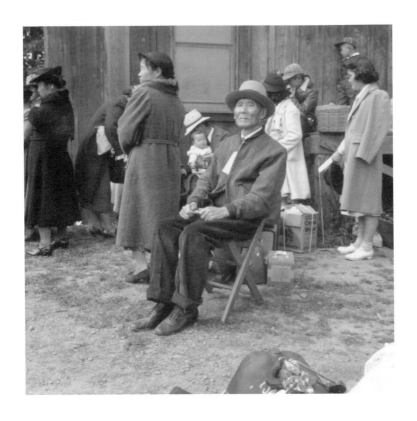

Centerville, California. A grandfather awaits evacuation bus.

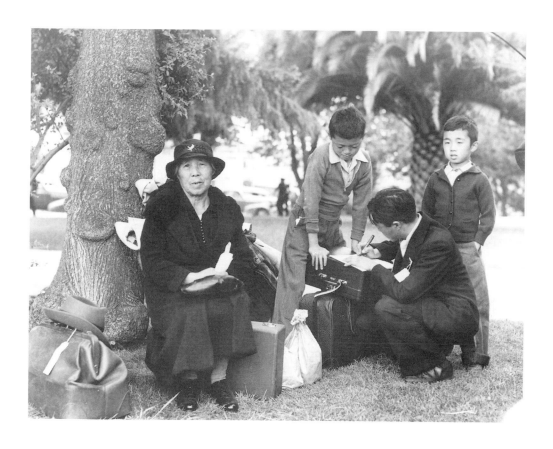

Hayward, California. Writing a letter to a brother in Texas as an
evacuee family awaits evacuation bus.

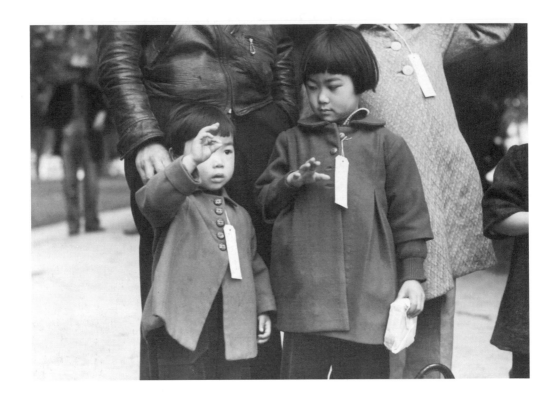

Hayward, California. Two children of the Mochida family who, with
their parents, are awaiting evacuation bus. The youngster on the
right holds a sandwich given her by one of a group of women who
were present from a local church.

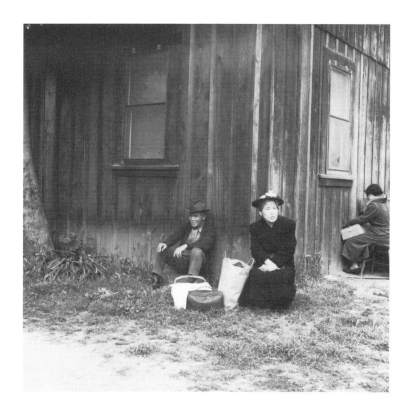

Centerville, California. This farming couple awaits evacuation bus.

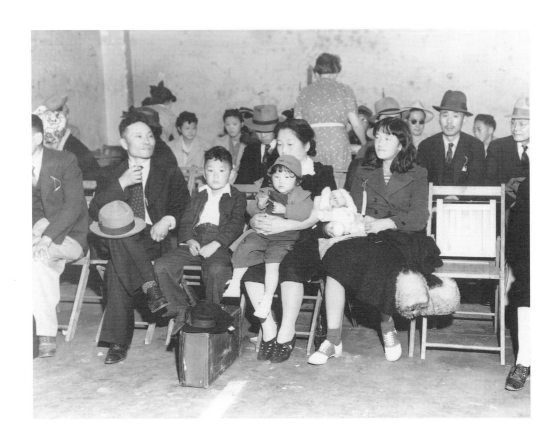

1117 Oak Street, Oakland, California. Evacuees at the WCCA
station awaiting evacuation bus for Tanforan Assembly Center
under Civilian Exclusion Order No. 28. Woman standing in
background is a local Caucasian church worker assisting in the
evacuation.

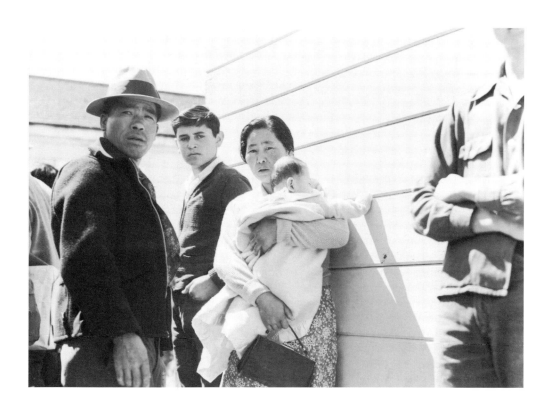

Byron, California. As families of Japanese ancestry are evacuated
from farms in Contra Costa County, they gathered at Wartime Civil
Control Administration station and awaited buses for assembly
center at Turlock Fairgrounds, 65 miles away. Boy in background is
a spectator.

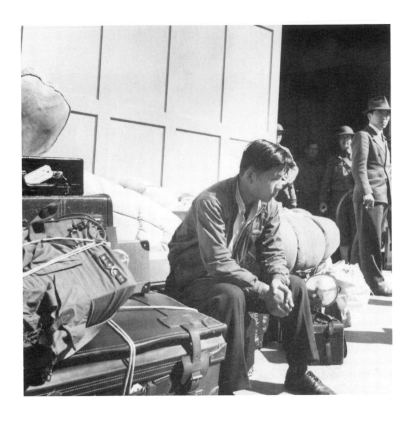

San Francisco, California. An early comer arrives with personal effects at 2020 Van Ness Avenue as part of the 664 residents of Japanese ancestry to be evacuated from San Francisco on April 6, 1942.

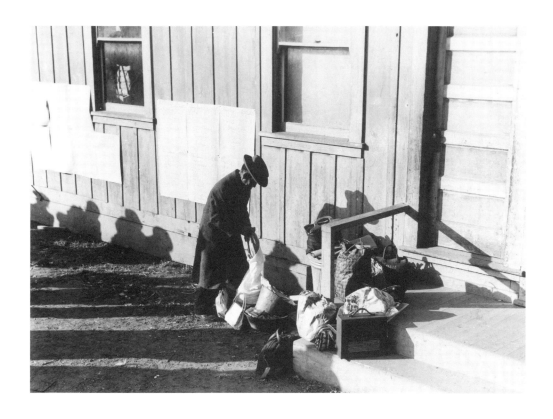

Centerville, California. This farmer rearranges his personal effects
as he awaits evacuation bus.

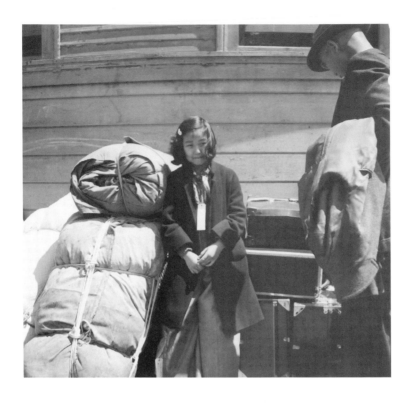

Oakland, California. Young evacuee of Japanese ancestry guarding the family belongings near the Wartime Civil Control Administration station. In half an hour the evacuation bus will depart for Tanforan Assembly Center.

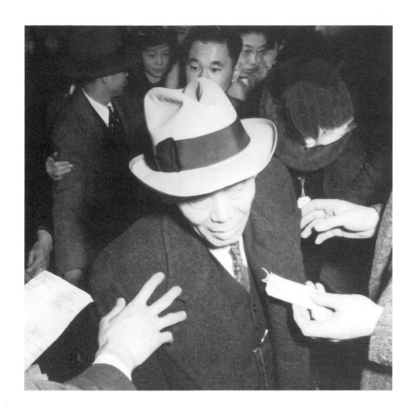

San Francisco, California. Just about to step into the bus for the
assembly center, April 6, 1942.

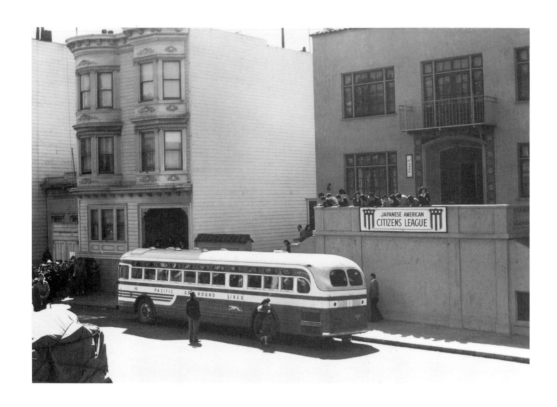

San Francisco, California. These evacuees of Japanese ancestry are part of a group of 600 persons being evacuated on this morning to the assembly center. The Japanese American Citizens League headquarters is being used as a Wartime Civil Control Administration station. Prior to evacuation orders it was used as a language school.

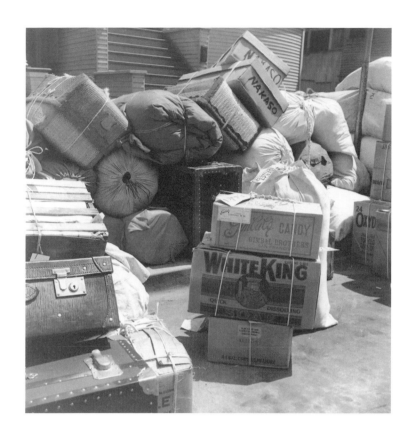

1117 Oak Street, Oakland, California. Baggage belonging to evacuees of Japanese ancestry, ready to be loaded into moving vans to be taken to Tanforan Assembly Center.

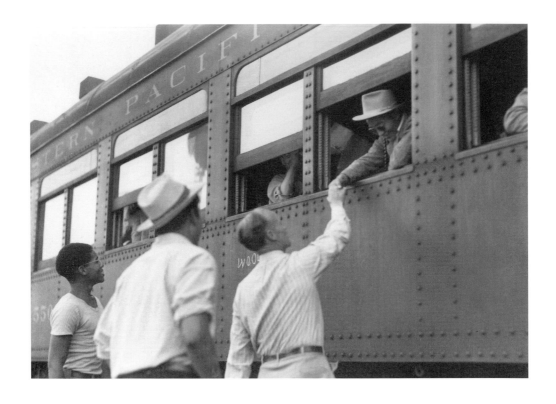

Woodland, California. Filled with evacuees of Japanese ancestry,
the special train is ready to depart from this rich agricultural
section for the Merced Assembly center, 125 miles away.

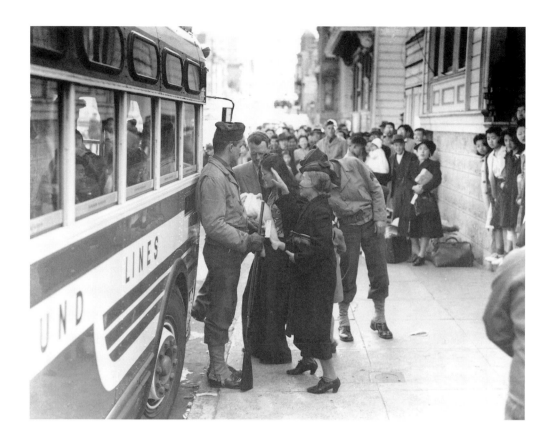

2031 Bush Street, San Francisco, California. Friends and neighbors
congregate to bid farewell, though not for long, to their friends who
are enroute to the Tanforan Assembly Center. They, themselves,
will be evacuated within three days.

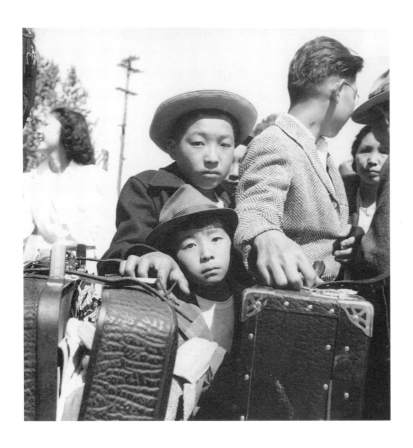

Turlock, California. These young evacuees of Japanese ancestry
are awaiting their turn for baggage inspection upon arrival at this
Assembly Center.

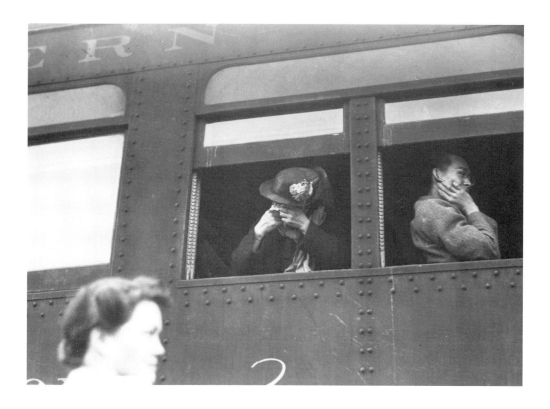

Woodland, California. Ten cars of evacuees of Japanese ancestry
are now aboard and the doors are closed. Their Caucasian friends
and the staff of the Wartime Civil Control Administration stations
are watching the departure from the platform. Evacuees are
leaving their homes and ranches, in a rich agricultural district,
bound for Merced Assembly Center.

AT THE ASSEMBLY CENTERS

Sacramento, California. View of Sacramento Assembly Center
seen across fields from road which approaches it. This center has
a capacity for 5,000 persons. It is situated eleven miles north of
the city.

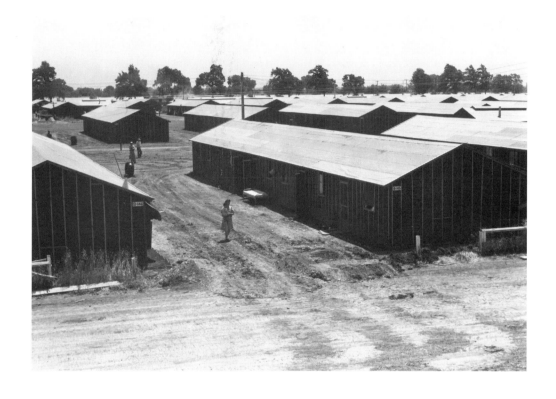

Stockton, California. Part of the Stockton Assembly Center as seen at noon on a hot day. This center has been open to evacuees of Japanese ancestry for one week.

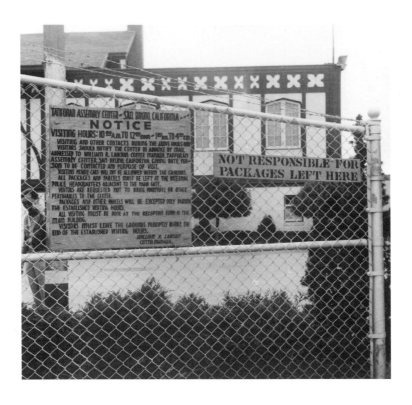

San Bruno, California. A sign at the main entrance of the Tanforan
Assembly Center, through which all traffic passes. The gate is
guarded and controlled by United States soldiers.

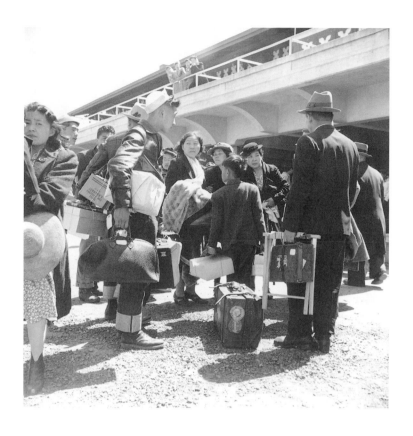

San Bruno, California. Family of Japanese ancestry arrives at
assembly center at Tanforan Race Track.

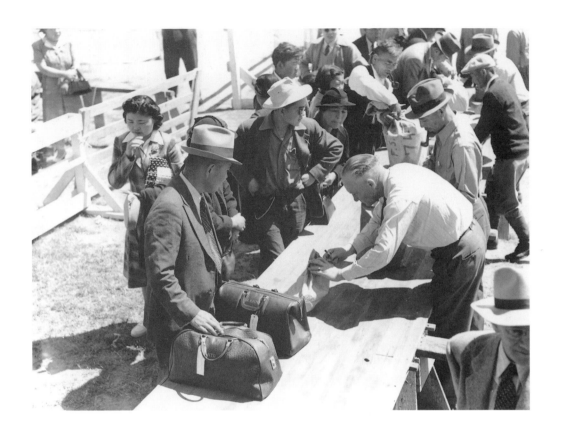

Turlock, California. Heads of families of Japanese ancestry are gathered about the table where their hand-baggage is being inspected for contraband before being admitted into the Assembly Center.

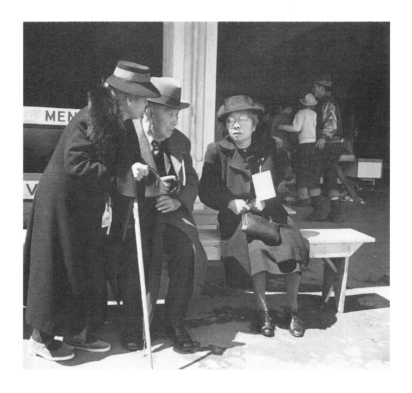

San Bruno, California. These older evacuees have just been registered and are resting before being assigned to their living quarters in the barracks. The large tag worn by the woman on the right indicates special consideration for aged or infirm.

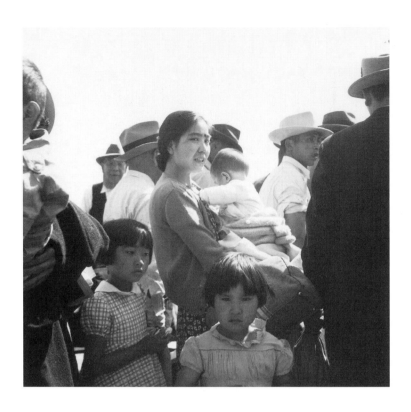

Turlock, California. Families of Japanese ancestry arrive at Turlock Assembly Center.

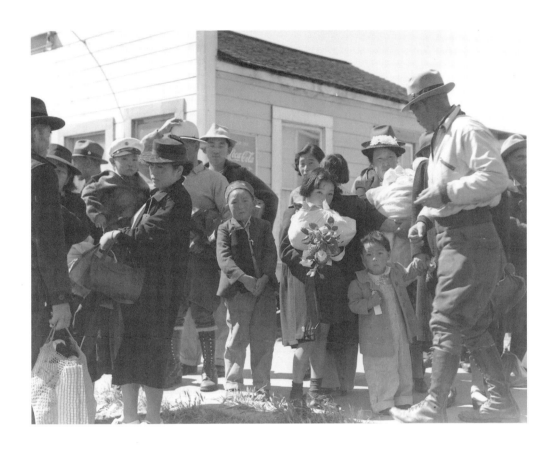

Turlock, California. Families of Japanese ancestry arrive at Turlock
Assembly Center.

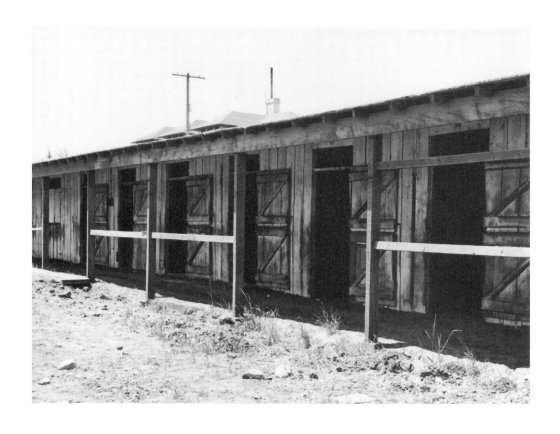

San Bruno, California. Near view of horse-stall, left from the days
when what is now Tanforan Assembly Center, was the famous
Tanforan Race Track. Most of these stalls have been converted into
family living quarters for Japanese.

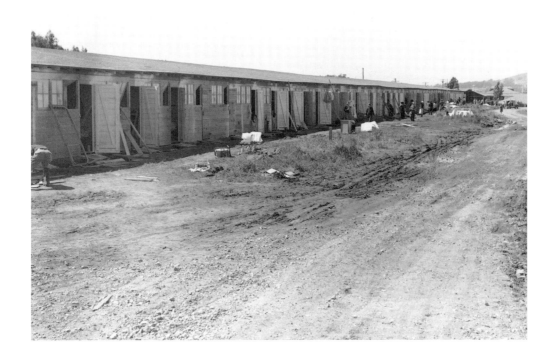

Tanforan Assembly Center, San Bruno, California. Barracks for
family living quarters. Each door enters into a family unit of two
small rooms (remodeled horse-stalls). Tanforan Assembly Center
was opened two days before this photograph was made. The people
shown in this photograph arrived this morning.

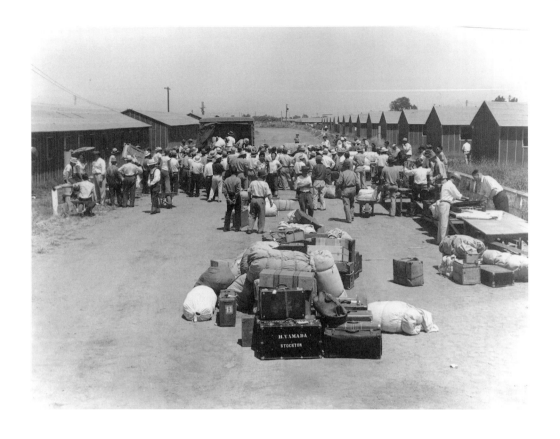

Stockton Assembly Center, Stockton, California. The first day at an assembly center. A new unit of the barracks is being opened today for the eight bus loads of arrivals. This photo shows the luggage and bed-rolls which have come in by truck, deposited here for inspection for contraband (note inspection table and official at right). Evacuees then take their possessions to the barracks to which they have been assigned.

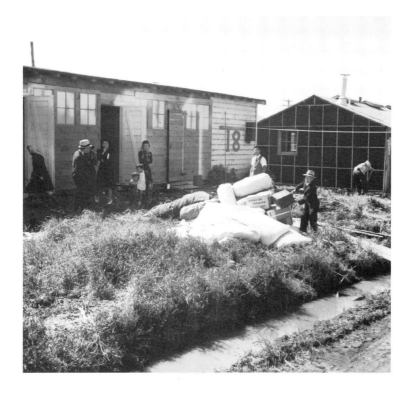

San Bruno, California. This assembly center has been open for two days. Bus-load after bus-load of evacuated Japanese are arriving today. After going through the necessary procedure, they are guided to the quarters assigned to them in the barracks. This family had just arrived. Their bedding and clothing have been delivered by truck and are seen piled in front of the former horse-stall to which they have been assigned. Unfortunately there have been heavy rains.

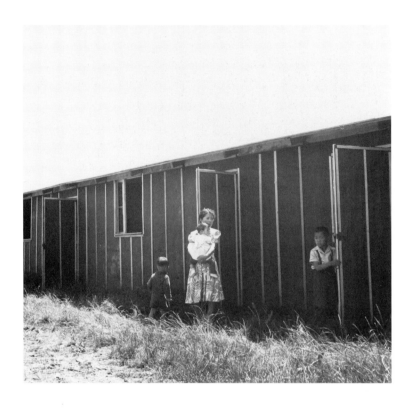

Stockton, California. This family just arrived in the Stockton center this morning. The mother and the children wait at the door of the room in the barracks to which they have been assigned, while the father is at the baggage depot where the bedding and clothing are being unloaded and inspected for contraband.

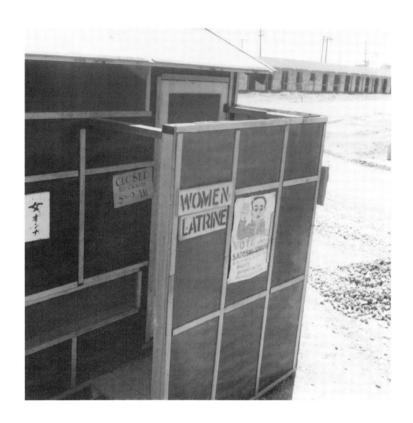

San Bruno, California. In this scene are shown sanitary facilities; campaign poster (5 Councilmen to be elected at general election) and a row of barracks beyond.

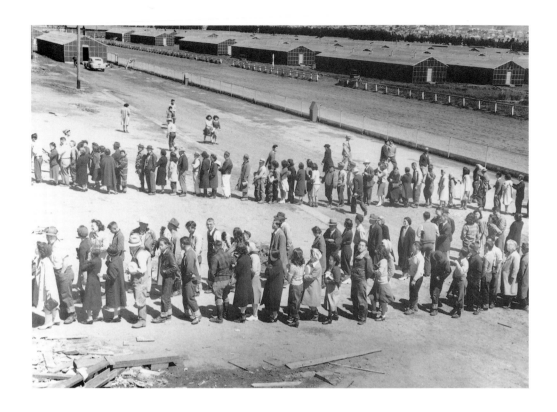

Tanforan Assembly Center, San Bruno, California. This assembly center has been open for two days. Bus-load after bus-load of evacuated persons of Japanese ancestry are arriving on this day. After going through the necessary procedures, they are guided to the quarters assigned to them in the barracks. Only one mess hall was operating today. Photograph shows line-up of newly arrived evacuees outside this mess hall at noon. Note barracks in background, just built, for family units. The wide road which runs diagonally across the photograph is the former race track.

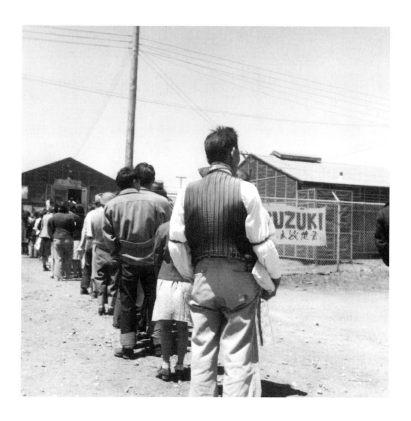

San Bruno, California. "Supper time" Meal times are the big events of the day at assembly centers. This is a line-up of evacuees waiting for the "B" shift at 5:45 pm. They carry with them their own dishes and cutlery in bags to protect them from the dust. They, themselves, individually wash their own dishes after each meal because dishwashing facilities in the mess halls proved inadequate. Most of the residents prefer this second shift because sometimes they get second helpings, but the shifts are rotated each week. There are eighteen mess halls that together accommodate 8,000 persons for three meals a day. All food is prepared and served by evacuees. The poster seen in the background advertises the candidacy of Mr. Suzuki for council for this precinct.

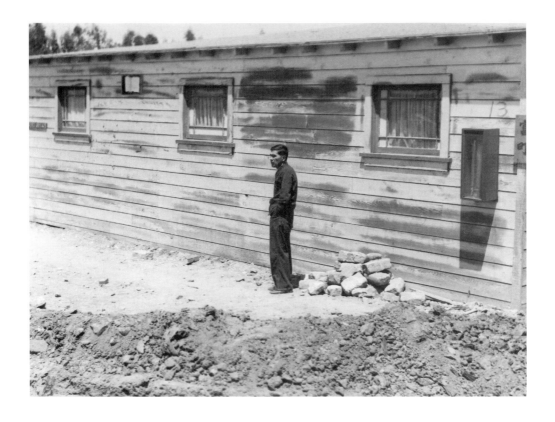

San Bruno, California. Many evacuees suffer from lack of their accustomed activity. The attitude of the man shown in this photograph is typical of the residents in assembly centers, and because there is not much to do and not enough work available, they mill around, they visit, they stroll and they linger to while away the hours.

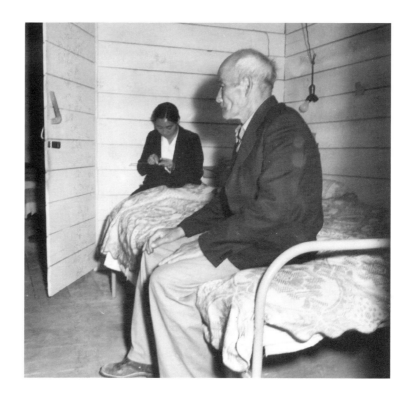

San Bruno, California. Old Mr. Konda in barrack apartment, after supper. He lives here with his two sons, his married daughter and her husband. They share two small rooms together. His daughter is seen behind him, knitting. He has been a truck farmer and raised his family who are also farmers, in Centerville, Alameda County where his children were born.

Sacramento, California. Masamichi Susuki and Bill
Sugiyama, roommates of Harvey Itano, at the Assembly Center.
Both boys have attended the University of California and Mr.
Sugiyama was accepted by the University of California Medical
School prior to evacuation, but is now unable to attend.

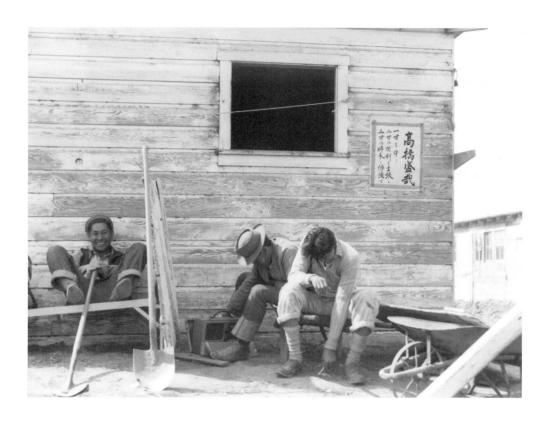

San Bruno, California. Time out for some of the boys on the Work
Corps. All maintenance work, repair and construction is done by
volunteer evacuee workers. The wages are $8.00 per month for 48
hours a week. This gang of boys and young men are digging a
drainage tank along one of the barracks.

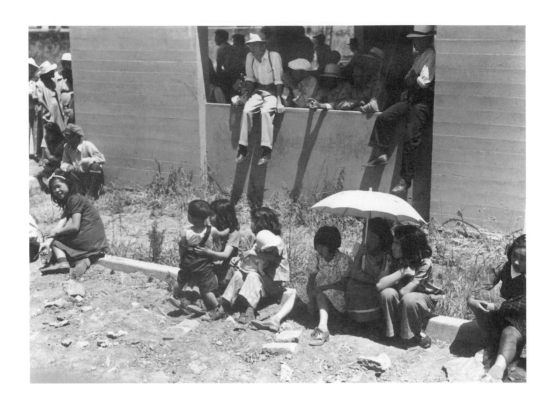

Stockton, California. These evacuees are watching the arrival of
buses bringing new groups of families to this assembly center.

San Bruno, California. A close-up of the exterior of a family unit.
These barracks were formerly horse-stalls. Each family is assigned
two small rooms. The interior one has neither outside door nor
window.

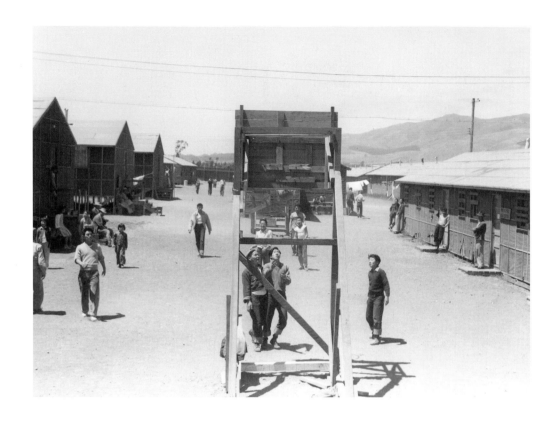

San Bruno, California. Evacuee boys in the foreground are playing basket-ball. This is one of eight recreation centers which are distributed about the assembly center. One of the barrack buildings is, in each case, set apart for games and recreation under the Recreation program administered by a Wartime Civil Control Administration official with college trained evacuee supervisors.

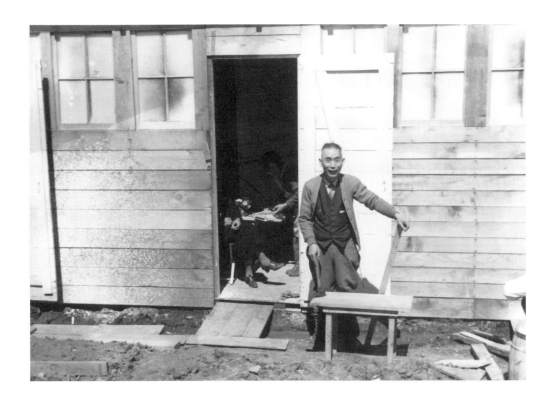

San Bruno, California. This family newly arrived, are in the process of settling down. The old man proudly exhibits the bench which he has just made out of scrap lumber left over from construction. The quarters to which this family were assigned are remodeled horsestalls.

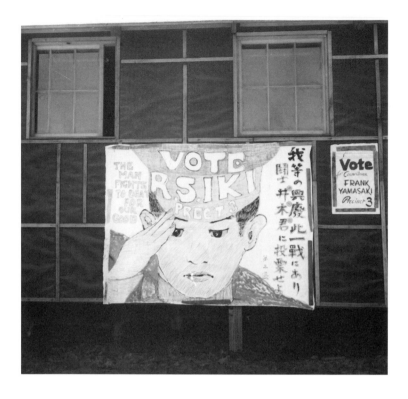

San Bruno, California. Buildings of the Tanforan Center are plastered at this time with all manner of locally devised posters incident to the election.

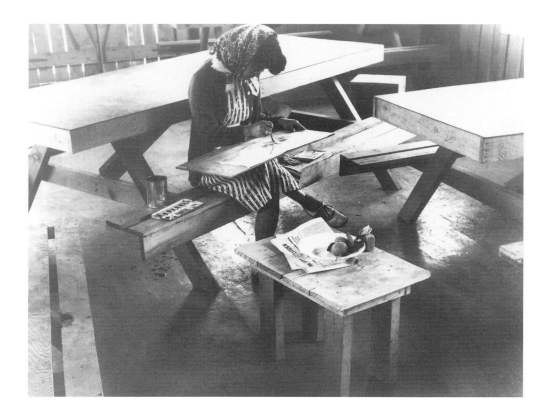

Tanforan Assembly Center, San Bruno, California. An art school
has been established in this Assembly Center with large
enrollment and a well trained, experienced Japanese staff under
the leadership of Prof. Chiura Obata of the University of California.
This photograph shows student in Still Life Class painting a free
water color.

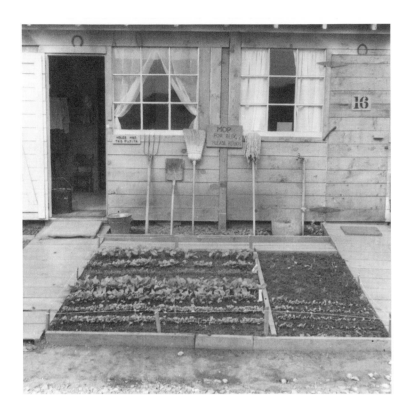

San Bruno, California. Close-up of barrack home with the carefully planned flower garden in foreground.

CHAPTER 4

MANZANAR

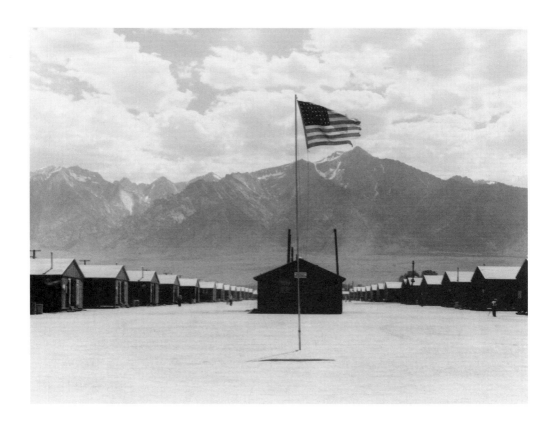

Manzanar, California. Dust storm at this War Relocation Authority center where evacuees of Japanese ancestry are spending the duration.

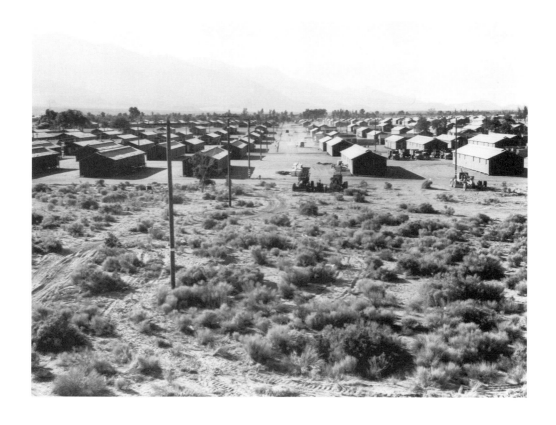

A view of the Manzanar Relocation Center showing streets and
blocks.

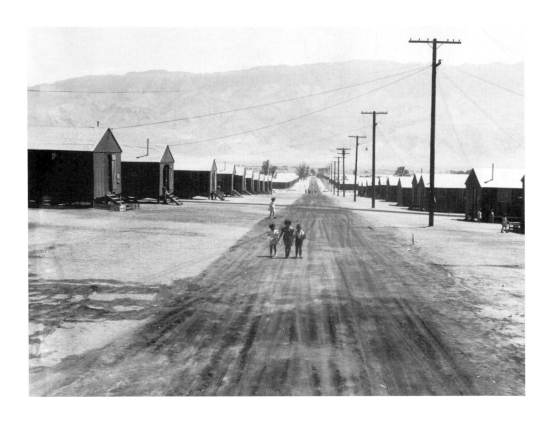

Street scene looking east toward the Inyo Mountains. The children
are coming to their barrack homes from play school.

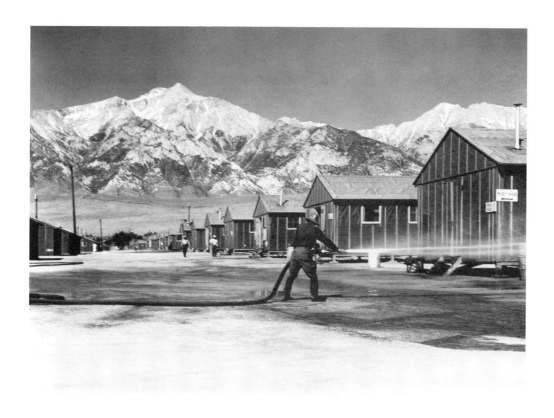

Fire equipment is used to keep the dust down at this center.

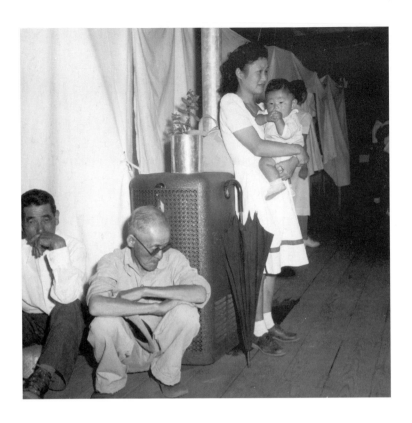

A typical interior scene in one of the barrack apartments at this center. Note the cloth partition which lends a small amount of privacy.

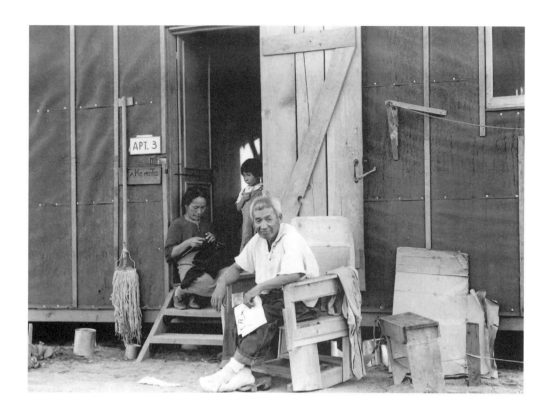

Evacuee family of Japanese ancestry relax in front of their barrack
room at the end of day. The father is a worker on the farm project
at this War Relocation Authority center. Note the chair, which was
made of scrap lumber, and the wooden shoes known as Getas
made by evacuees.

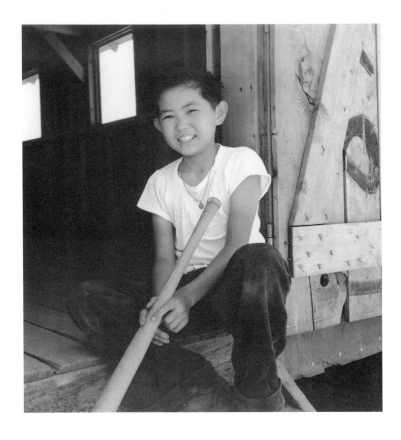

Manzanar, California. Evacuee boy waiting at the entrance of the Recreational Hall at this War Relocation Authority center. He is anxious for the baseball team to assemble.

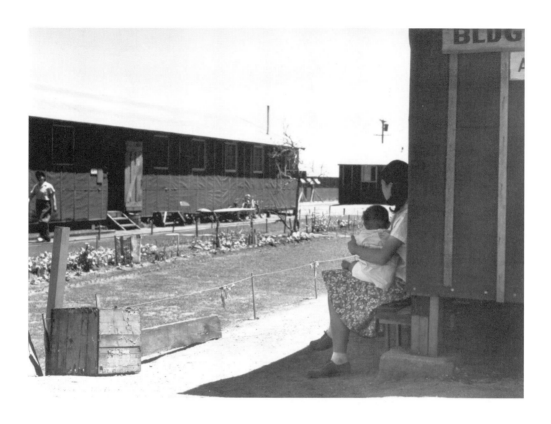

Lawns and flowers have been planted by some of the evacuees at
their barrack homes.

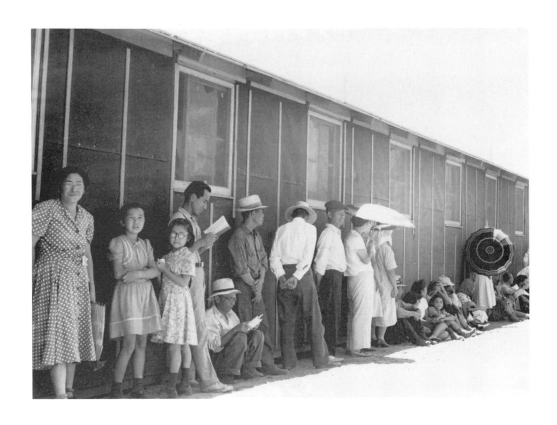

Part of a line waiting for lunch outside the mess hall at noon.

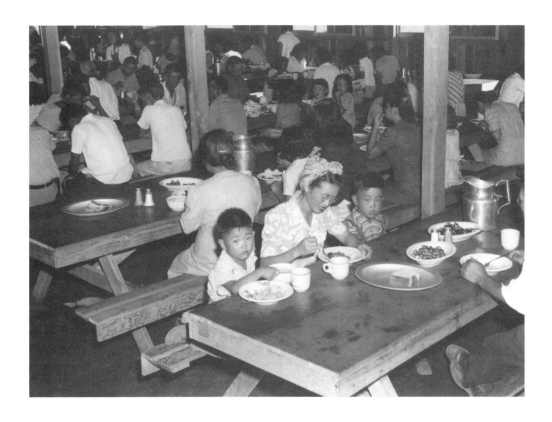

Mealtime in one of the mess halls at this center.

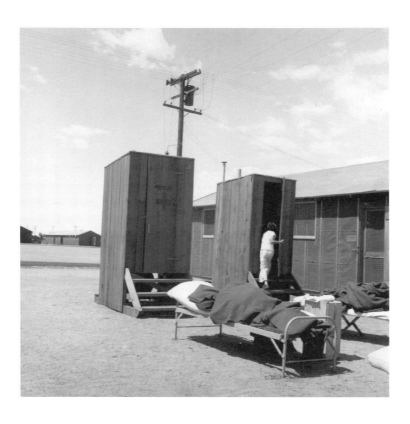

Hospital latrines, for patients, between the barracks, which serve
temporarily as wards. For the first three months of occupancy
medical facilities have been meager but the new hospital, fully
equipped, is almost ready for occupancy.

Women's ward in the temporary barracks hospital at this War Relocation Authority center for evacuees of Japanese ancestry. The new hospital with accommodations for 250 beds is almost ready for occupancy.

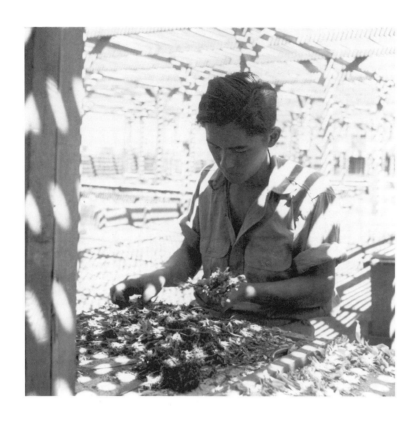

An evacuee is shown in the lath house sorting seedlings for transplanting. These plants are year-old seedlings from the Salinas Experiment Station.

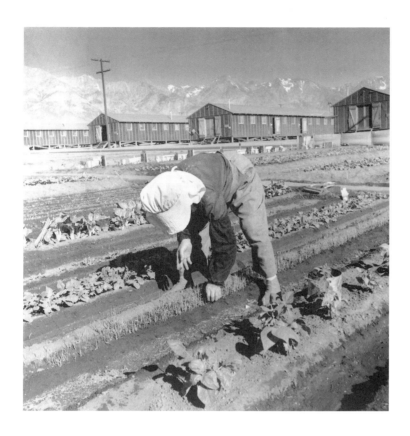

Manzanar, California. Evacuee in her "hobby garden" which rates highest of all the garden plots at this War Relocation Authority center. Vegetables for their own use are grown in plots 10 × 50 feet between rows of barracks.

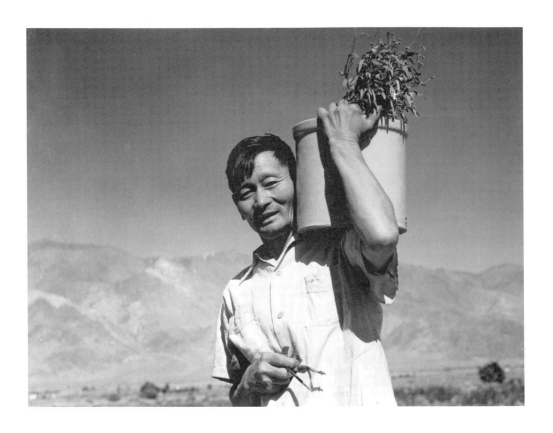

George J. Yokomizo, hybridizer for the guayule rubber experiment project, outside the lath house with one of the guayule plants from which he hopes to develop seed.

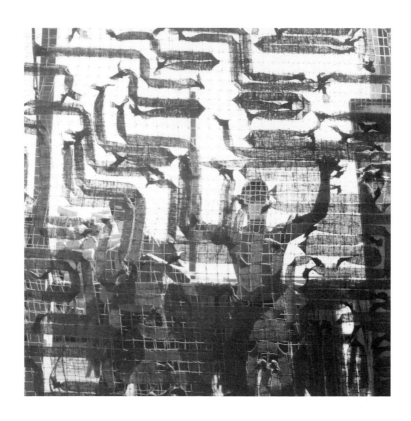

Making camouflage nets for the War Department. This is one of
several War and Navy Department projects carried on by persons
of Japanese ancestry in relocation centers.

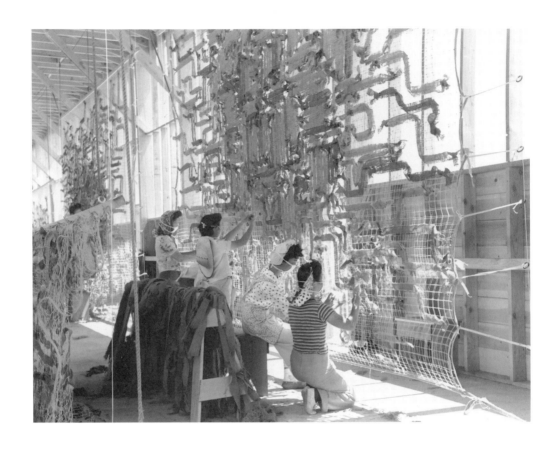

Manzanar Relocation Center, Manzanar, California. Making
camouflage nets for the War Department.

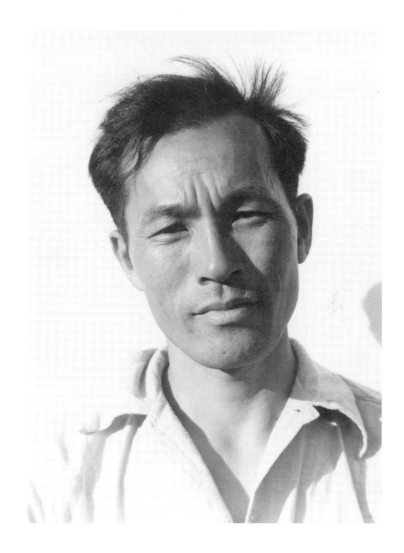

Karl Yoneda, Block Leader at this War Relocation Authority
center for evacuees of Japanese ancestry. He is married to a
Caucasian and they have a child four years old. The family is
spending the duration at this center.

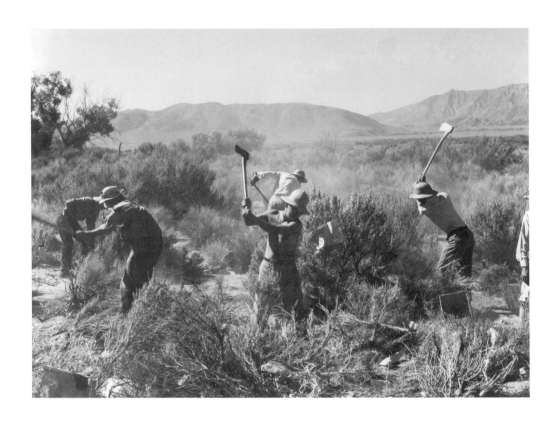

More land is being cleared of sage brush at the southern end of the project to enlarge this War Relocation Authority center.

Evacuees are growing flourishing truck crops for their own use in
their "hobby gardens." These crops are grown in plots 10 × 50 feet
between blocks of barracks.

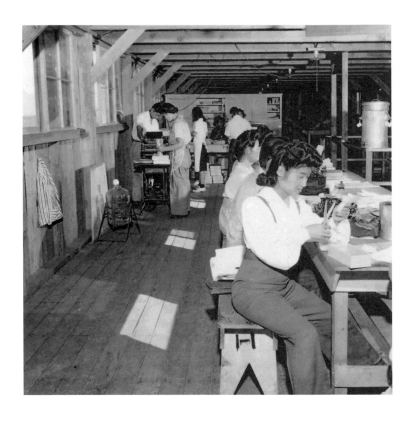

Staff of the *Manzanar Free Press* at work. This is the local
mimeographed paper of happenings at this War Relocation
Authority center published by evacuees interested in this work.
Most of the items are written in English, with but one page
translated into Japanese.

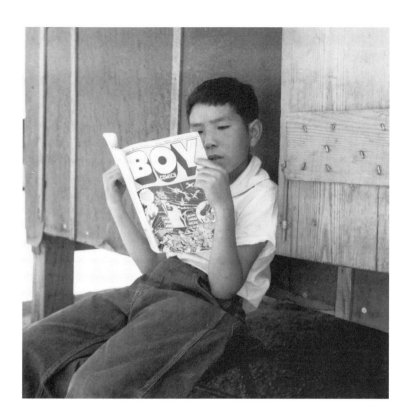

Evacuee boy reading the Funnies.

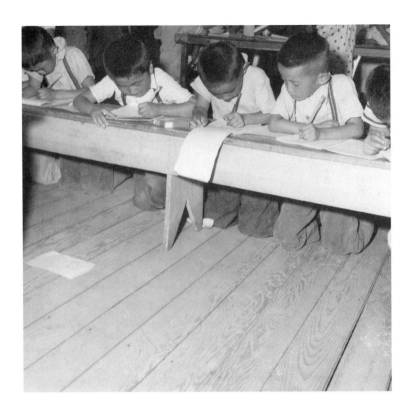

An elementary school with voluntary attendance has been established with volunteer evacuee teachers, most of whom are college graduates. No school equipment is as yet obtainable and available tables and benches are used.

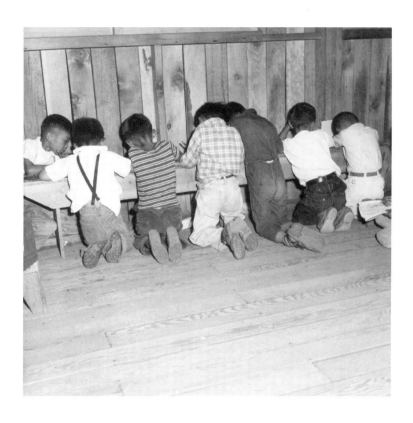

Third grade students working on their arithmetic lesson.

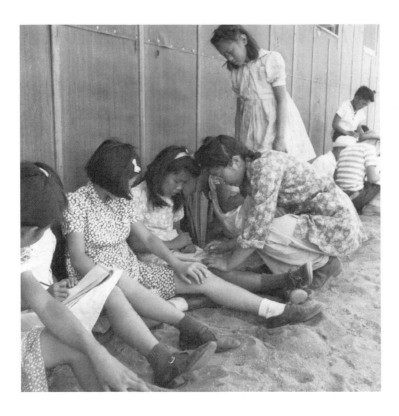

Classes are often held in the shade of the barrack building at this
War Relocation Authority center.

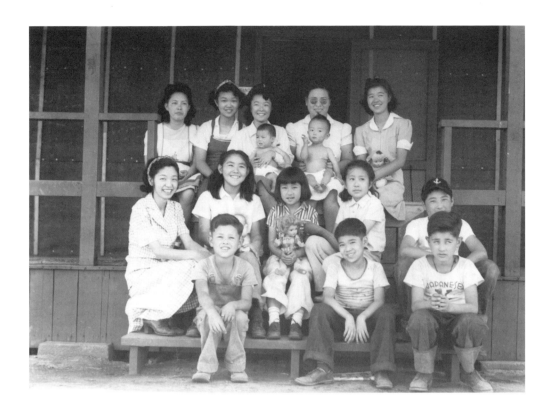

Evacuee orphans from an institution in San Francisco who are now
established for the duration in the Children's Village at this War
Relocation Authority center for evacuees of Japanese ancestry.
Mrs. Harry Matsumoto, a University of California graduate, and her
husband are superintendants of the Children's Village where 65
evacuee orphans from 3 institutions are now housed.

Evacuees enjoying games under the shade of trees near the creek
which flows through the desert on the border of this center.

Evacuees enjoying a hot summer afternoon. This mountain stream
flows through the desert on the border of the Center.

Evacuees watching a ball game late in the afternoon.

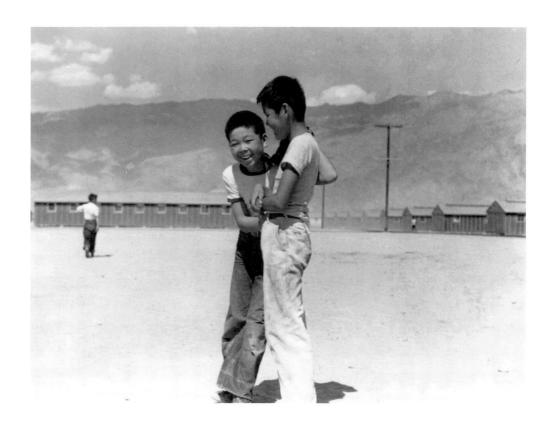

Young evacuees.

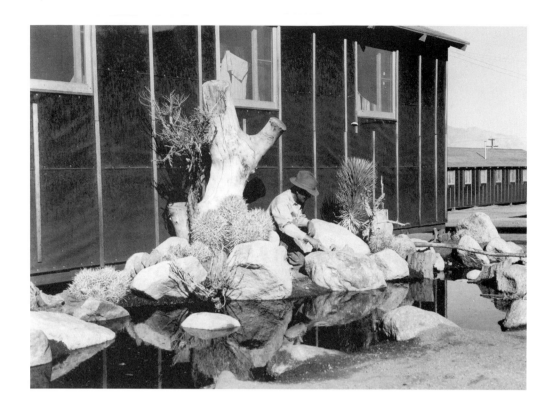

William Katsuki, former professional landscape gardener for large estates in Southern California, demonstrates his skill and ingenuity in creating from materials close at hand, a desert garden alongside his home in the barracks.

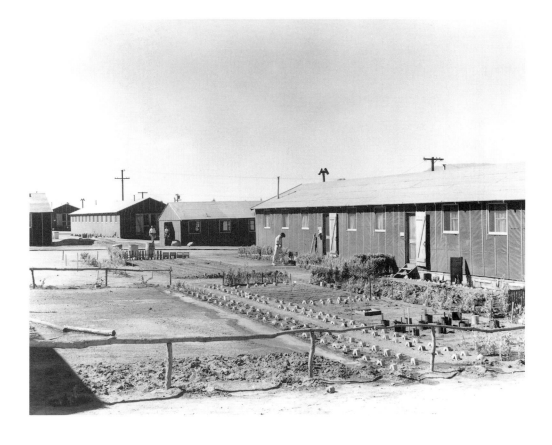

Manzanar, California. There are many evidences of skill and
ambition within this War Relocation Authority center for evacuees
of Japanese ancestry, as seen by the flower garden under
construction in the foreground. This family was in the nursery
business before evacuation.

In the Art School at this War Relocation Authority center.

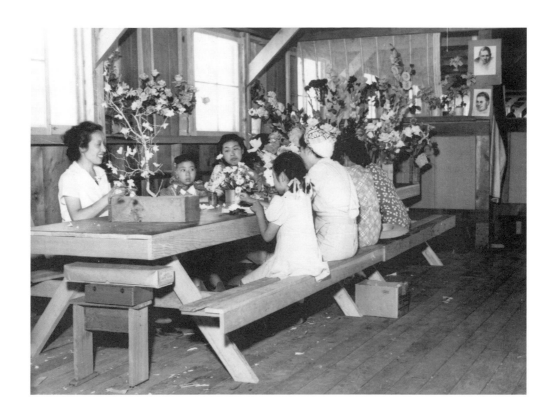

Making artificial flowers in the Art School.

The first grave at the Manzanar Center's cemetery. It is that of Matsunosuke Murakami, 62, who died of heart disease on May 16, 1942. He had been ill ever since he arrived here with the first contingent and had been confined to the hospital since March 23.

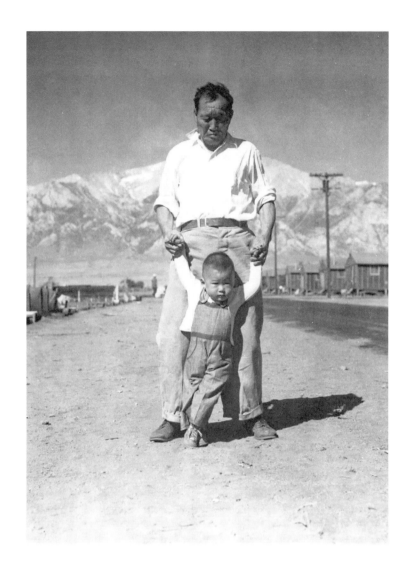

Grandfather of Japanese ancestry teaching his little grandson to walk at this War Relocation Authority center for evacuees.

ACKNOWLEDGMENTS

Linda Gordon would like to thank the many members of the extended Lange/Dixon/Taylor/Partridge family who gave me some of their time and recollections: Daniel Dixon, John Dixon, Helen, Andy, Lisa and Gregor Dixon, Donald Fanger, Becky Jenkins, Betsy Partridge, Meg Partridge, Rondal Partridge, Dyanna Taylor, and Onnie Taylor. They are impressive in their desire not only to honor Dorothea Lange's work but also to think critically about it. Two documentary photographers who worked with Lange—Pirkle Jones and Rondal Partridge—were particularly helpful, and I am grateful. Above all I relied on the recollections of Christina Page Gardner, who was Lange's assistant during her Japanese internment work; Chris not only gave me time but wrote me detailed notes on an early draft. I am in debt to several archivists and curators, notably Beverly Brannan, the late Therese Heyman, Drew Johnson, Bill McMorris, Nicholas Natanson, and several anonymous staff members of the National Archives' Still Pictures Division who helped me locate particular hard-to-find images. My interpretations have benefited above all from the scholarship of Sally Stein. For extremely helpful comments I would like to thank Ros Baxandall, George Chauncey, Dick Cluster, Phyllis Ewen, Allen Hunter, Elizabeth Kendall, Milton Meltzer, and Jean Strouse. Barrie Thorne, Honey Williams, and Gail Saliterman graciously provided places to stay in the Bay Area and Carmel. Thanks to Tariq Ali for proposing this book, although it did not turn out as he hoped. My special gratitude to Gary Y. Okihiro, who not only agreed to work with me before we'd ever met but also proved a kindred spirit and reliable collaborator in the interests of justice. Thanks of a different kind for the extraordinary Betsy Mayer, who has been supportive and generous from the

moment I began to think seriously of writing about Lange, and the late Henry Mayer, who, although I never met him, made me an unknowing gift of some extraordinary research. The Norton family is an unusually sane and human group to work with; thanks to Bob Weil, Rubina Yeh, and Tom Mayer.

Gary Y. Okihiro would like to thank Linda Gordon for inviting him to join her in this wonderful collaboration, and Marina A. Henriquez for her research assistance.

Linda Gordon and Gary Okihiro want to thank Roger Daniels and Edward McCarter not only for their help but for their great store of knowledge.

BIBLIOGRAPHY

John Armor and Peter Wright. *Manzanar*. New York: Times Books, 1998.
Commentary by John Hersey and photographs by Ansel Adams.

Richard Bolton, ed. *The Content of Meaning: Critical Histories of Photography*.
Cambridge: Massachusetts Institute of Technology Press, 1989.

Elena Tajima Creef. *Imaging Japanese America: The Visual Construction of
Citizenship, Nation, and the Body*. New York: New York University Press,
2004.

Pete Daniel, Merry A. Foresta, Maren Stange, and Sally Stein. *Official Images:
New Deal Photography*. Washington, D.C.: Smithsonian Institution, 1987.

Roger Daniels. *Concentration Camps: North America, Japanese in the United
States and Canada During World War II*. Malabar, Fla.: Robert E. Krieger,
1981.

———. *Prisoners Without Trial: Japanese Americans in World War II*. New York:
Hill and Wang, 1993.

Judith Fryer Davidov. " 'The Color of My Skin, the Shape of My Eyes':
Photographs of the Japanese American Internment by Dorothea Lange,
Ansel Adams, and Toyo Miyatake." *Yale Journal of Criticism* 9:2 (1996):
223–44.

Stephen S. Fugita and Marilyn Fernandez. *Altered Lives, Enduring Community:
Japanese Americans Remember Their World War II Incarceration*. Seattle:
University of Washington Press, 2004.

Jonathan Harris. *Federal Art and National Culture: The Politics of Identity in
New Deal America*. Cambridge, England: Cambridge University Press,
1995.

Therese Thau Heyman, ed. *Dorothea Lange: American Photographs*. San Francisco: Museum of Modern Art, 1994.

Tetsuden Kashima. *Judgment Without Trial: Japanese American Imprisonment during World War II*. Seattle: University of Washington Press, 2003.

Mitchell T. Maki, Harry H. L. Kitano, and S. Megan Berthold. *Achieving the Impossible Dream: How Japanese Americans Obtained Redress*. Urbana: University of Illinois Press, 1999.

Milton Meltzer. *Dorothea Lange: A Photographer's Life*. New York: Farrar, Straus and Giroux, 1978.

Eric L. Muller. *Free to Die for Their Country: The Story of the Japanese American Draft Resisters of World War II*. Chicago: University of Chicago Press, 2001.

Karin Becker Ohrn. *Dorothea Lange and the Documentary Tradition*. Baton Rouge: Louisiana State University Press, 1980.

Gary Y. Okihiro. *Cane Fires: The Anti-Japanese Movement in Hawaii, 1865–1945*. Philadelphia: Temple University Press, 1991.

Gary Y. Okihiro and Joan Myers. *Whispered Silences: Japanese Americans and World War II*. Seattle: University of Washington Press, 1996.

Miné Okubo. *Citizen 13660*. New York: Columbia University Press, 1946.

Elizabeth Partridge, ed. *Dorothea Lange: A Visual Life*. Washington, D.C.: Smithsonian Institution, 1994.

Personal Justice Denied. Report of the Commission on Wartime Relocation and Internment of Civilians. Seattle: University of Washington Press, 1997.

Greg Robinson. *By Order of the President: FDR and the Internment of Japanese Americans*. Cambridge, Mass.: Harvard University Press, 2001.

Allan Sekula. "Photography Between Labour and Capital." In *Mining Photographs and Other Pictures: A Selection from the Negative Archives of Shedden Studio, Glace Bay, Cape Breton*. Edited by Leslie Shedden. Cape Breton: Press of the Nova Scotia College of Art and Design, 1983.

Sally Stein. "Peculiar Grace: Dorothea Lange and the Testimony of the Body." In *Dorothea Lange: A Visual Life*. Edited by Elizabeth Partridge. Washington: Smithsonian Press, 1994.

———. "Portraiture's Veil." In *Dorothea Lange: The Human Face*. Paris: NBC éditions, 1998.

Richard Steven Street. "Paul S. Taylor and the Origins of Documentary Photography in California, 1927–1934." *History of Photography* 7:4 (1983): 293–304.

John Tagg. *The Burden of Representation: Essays on Photographies and Histories.* Amherst: University of Massachusetts Press, 1988.

ABOUT THE AUTHORS

Linda Gordon is a professor of history at New York University. Previously she taught at the University of Wisconsin/Madison and the University of Massachusetts/Boston. A graduate of Swarthmore College with a Ph.D. from Yale University, her scholarship was influenced by the progressive social movements of the 1950s and 1960s. The questions those movements raised led her to examine the historical roots of contemporary social policy debates, particularly as they concern gender and family issues. These books included *The Moral Property of Women: The History of Birth Control in the U.S.* (a revision of a book originally published in 1976), in 2002; *Heroes of Their Own Lives: The History and Politics of Family Violence*, in 1988; and *Pitied But Not Entitled: Single Mothers and the History of Welfare,* in 1994. Experimenting with writing in a storytelling voice, in 1999 Gordon published *The Great Arizona Orphan Abduction*, a narrative about a 1904 white vigilante action against the Mexican American foster parents of white children. It was the winner of the Bancroft Prize for best book in American history and the Beveridge Prize for best book on the history of the Americas. She is now completing a biography of Dorothea Lange.

Gary Y. Okihiro is professor of international and public affairs and director of the Center for the Study of Ethnicity and Race at Columbia University. He received his Ph.D. in African history at UCLA, and has taught at several universities including Cornell and Princeton. Six of his eight books have won national book awards, and their subject matters range from African to U.S. history. He is perhaps best known for his *Margins and Mainstreams: Asians in American History and Culture,* and *Common Ground: Reimagining American History.* He is a recipient of the Lifetime Achievement Award from the American Studies Association, and is a past president of the Association for Asian American Studies.